Create Your Life Book

CREATE YOUR

Life
Book

Mixed-Media Art Projects for Expanding
Creativity and Encouraging Personal Growth

TAMARA LAPORTE

Quarto.com

© 2018 Quarto Publishing Group USA Inc.
Text, photography, and projects © 2018 Tamara Laporte

First Published in 2018 by Quarry Books, an imprint of The Quarto Group,
100 Cummings Center, Suite 265-D, Beverly, MA 01915, USA.
T (978) 282-9590 F (978) 283-2742

Quarry Books titles are also available at discount for retail, wholesale, promotional, and bulk purchase. For
details, contact the Special Sales Manager by email at specialsales@quarto.com or by mail at The Quarto
Group, Attn: Special Sales Manager, 100 Cummings Center, Suite 265-D, Beverly, MA 01915, USA.

11

ISBN: 978-1-63159-353-6

Digital edition published in 2018

Library of Congress Cataloging-in-Publication Data

Names: Laporte, Tamara, author.
Title: Create your life book : mixed-media art projects for expanding
 creativity and encouraging personal growth / Tamara Laporte.
Description: Beverly, MA : Quarry Books, 2018.
Identifiers: LCCN 2017029108 | ISBN 9781631593536 (paperback)
Subjects: LCSH: Mixed media (Art)--Technique. | Creative ability. |
 Self-actualization (Psychology) | BISAC: CRAFTS & HOBBIES / Mixed Media. |
 ART / Mixed Media.
Classification: LCC TT857 .L37 2018 | DDC 745.5--dc23 LC record available at
 https://lccn.loc.gov/2017029108

Cover and Book design: Kelley Galbreath
Cover Image: Tamara Laporte

Printed in China

The information in this book is for educational purposes only. It is not intended to replace
the advice of a physician or medical practitioner.

This book is dedicated to my husband and best friend, Andy Mason, without whom none of what I do would be possible. He is the light of my life, the rock I lean on, and the one who inspires me to live compassionately every day. Thank you for always cheering me on and for believing in me. I love you.

i am a beautiful

Contents

expression of the universe

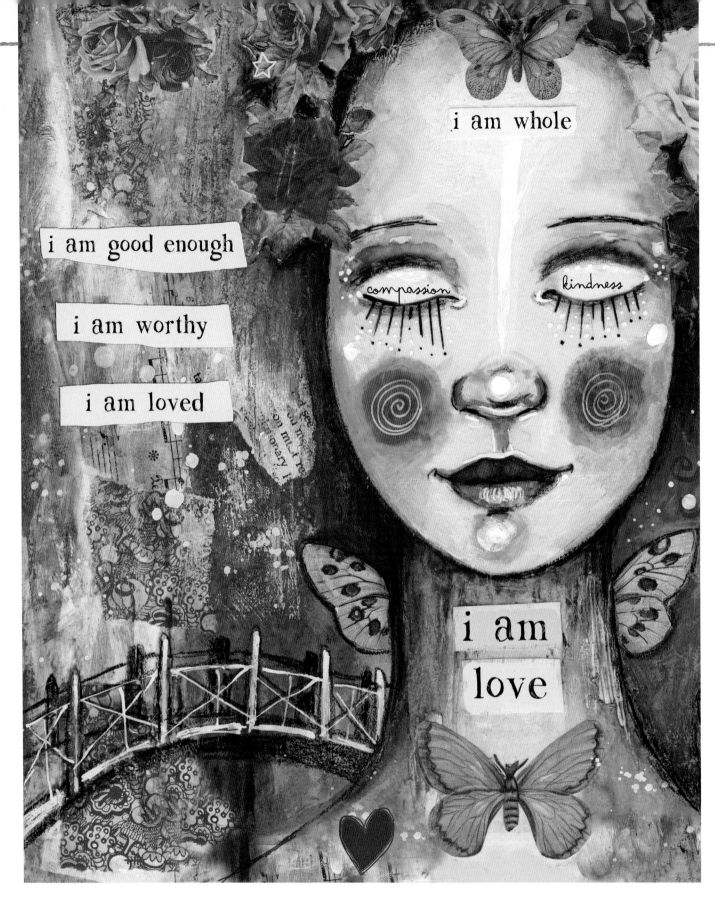

i am whole

compassion kindness

i am good enough

i am worthy

i am loved

i am love

Introduction

I BELIEVE THAT WORLD PEACE starts with happy people. When I look at the world and the violence I witness, I can't help but see deep emotional wounds being played out. It's clear to me that a happier world starts by healing the wounds within. I often say, "Happy people do happy things; unhappy people do unhappy things." I truly believe that.

I believe deeply that self-aware people who truly love themselves unconditionally are healthier and happier. They radiate light into the world. The unburdened person is free to be of service to others and live an inspired, productive life.

Ignoring old wounds and allowing them to fester can negatively affect our health, relationships, and quality of life.

To love oneself and to pursue happiness and contentment is not selfish. To love oneself is doing the world a favor.

This is why I do the work that I do, and it's what my book is about: It is my deepest wish to help ease the suffering in the world. I do this by helping people heal and love themselves through the creative process.

The intention of this book is to share several creative exercises combined with personal development exercises that foster self-love, personal growth, healing, and self-esteem improvement.

I hope this book helps and supports you on your creative and personal development journey. I hope it helps you love the glorious, amazing, wonderful person that you are and that it helps you see your power, see your worth, see the shining star that you are, and spread your light to make this world that much better. Thank you for opening this book; it gives me hope that you did.

What Is Life Book?

Life Book was first born in 2011 as a yearlong, online mixed-media art course with a personal development and healing focus. I created it to help people grow both creatively and personally through a wide variety of artistic and personal explorations. It has always been my deepest wish to help people find more self-love and self-worth so that we may collectively feel better and do better—for ourselves, our families, our friends, and the world.

Each week during the Life Book course, students receive uplifting and inspiring mixed-media lessons exploring topics such as self-love, the inner critic, creative block, and transforming limiting beliefs. Each year, between sixteen and twenty-two contributing guest teachers share their creative techniques as well as their insights on a healing theme. The pages created throughout the course end up bound into one big, beautiful book by the end of the year: A Life Book. This book serves as a keepsake and honoring of the journey the person has gone through. Thousands of Life Books have been created all over the world since it all started.

More than 16,000 people have joined Life Book worldwide since its inception. People find it life-enriching, enlightening, and eye-opening. It's often described as a

"all children are born artists. the problem is to remain an artist as we grow up."

—pablo picasso

lifeline by people who are going through difficult times in their lives.

For this book, I've hand-picked some of the most popular and life-transforming projects from the first six years of Life Book. I hope they will help you grow your creative and self-love wings.

The Life Book projects in this book can be done as stand-alone activities, or you can do them as a group and eventually bind them into a book (see page 131). This is an optional step. If you do want to bind your pages into a book at some point, be sure to create your projects on single sheets and do not work on the backs.

A Life Book project can be started at any point in one's life. There are no rules, shoulds, or musts; it's a safe space for you to explore your creative self and gently tend to the tender bits of you.

How Creativity Can Help You Heal

The creative process can be used as a tool for expressing ourselves on the page or canvas to improve our physical, emotional, and psychological well-being. Once we engage in expressive art-making, magical doors open and we can find ourselves understanding and resolving painful issues as well as reducing stress, managing behaviors and strong emotions, and improving our awareness and self-confidence.

Our creative selves are our magical selves. Creativity, to me, is at its essence self-connection

and communication. It's a gateway to intimate conversations with parts of myself I may not have access to through other means.

I have found that when people engage in the creative process, they enter a safe space in which they can be more freely themselves and feel less inhibited. They get more intimately acquainted with their inner vulnerable selves and become more deeply aware of their thoughts, feelings, and needs.

This awareness frequently serves to help people grow personally and heal unresolved pain.

The creative process is accessible to anyone, so long as a playful, nonjudgmental approach to creating is taken. No talent or previous experience is needed—just a willingness to play and be open to fluidly responding to your inner world, colors, brushstrokes, layers, and mark-making. It's fun and joyful too!

Although the creative process on its own can be meditative, cathartic, and healing, this book also includes some very intentional personal develop-ment exercises that focus on specific issues. They are woven into the creative process while providing an opportunity to find a deeper understanding and compassion for ourselves.

Art is a vehicle for discovery, for exploration. It's a path to letting go, allowing, and surrendering. Creativity is a tool for finding courage, being brave, and facing your demons. It's a mirror and a friend. It's a way to tend to your tender heart, to find your-self, and to shower yourself with the unconditional love you deserve.

A word of care: The projects in this book are intended as supplemental to any therapy you may already be undergoing. Please do not consider them a replacement for therapy. For the purposes of protec-tion and safety, work with issues that have a minor emotional charge. Once you feel familiar with the exercises and if you found them beneficial, you can work on more intense issues, but only do so within the boundaries of your own limitations, and be sure to have a support network around you in the form of family, friends, and/or a medical professional such as a therapist.

About Art Supplies

IN THIS BOOK, you will be introduced to a wide variety of materials and supplies. You do not need to buy them all. Many of the products used in this book can be replaced with other products you may already have or cheaper alternatives. Initially work with what you already have; if a particular product really speaks to you, you may want to buy it later.

Here is a list of products used in this book and possible substitutions for them, where applicable.

PAPER

- I work on 140 lb (300 g/m²) hot pressed water-color paper. Brand-wise, I usually use Daler-Rowney or Saunders Waterford, but Fabriano, Strathmore, or Canson would also be fine. I work either on 9 x 12 inch (23 x 30.5 cm) or 12 x 16 inch (30.5 x 41 cm). Cold pressed is fine, too. (Hot or cold pressed becomes a personal preference over time; cold pressed paper has a grain while hot pressed paper is smooth.) Don't go for less than 140 lb (300 g/m²) in weight.
 - » SUBSTITUTES: *I tend not to compromise on paper because wet work is hard on paper. You need high quality paper so it withstands the kind of mixed-media work we do in this book.*
- You can also do these projects in an art journal or on canvas, wood, or board. These substrates will respond slightly differently to your supplies. It's fun to explore and discover how all your supplies and substrates interact. A few projects in this book are demonstrated on canvas and canvas board.

PAINTS & CRAYONS

- Water-soluble crayons such as Caran d'Ache Neocolor II artists' crayons.
 - » SUBSTITUTES: *Any watercolor paints or watercolor pencils. Note: These may not be as vibrant as the crayons.*
- Golden Heavy Body Acrylic Paints.
 - » SUBSTITUTES: *Daler-Rowney or Winsor & Newton heavy body acrylic paints. Even student-grade paints will be fine if you are just beginning.*
- Golden Fluid Acrylic Paints. These are expensive, so if you want to try them out, buy two or three of your favorite colors to start with.

» SUBSTITUTES: *Water-down heavy body acrylics or add glazing or matte medium to your heavy body acrylics. Some other cheaper brands also do fluid acrylics.*

• Fun but expensive and optional: Golden High Flow Acrylic Paints. Get only a few if you want to try them.

» SUBSTITUTES: *Fluid acrylics or watered-down heavy body acrylic paints can create a similar effect. You can also use acrylic markers (such as Posca markers) to achieve a similar effect. The downside is that the colors vary by brand.*

PENCILS

• Colored pencils by brands such as Prismacolor or Caran d'Ache Luminance.
• Water-soluble colored pencils by brands such as Derwent or Stabilo All.
• Graphite pencils, 2B and heavier. I like the Graph Gear 1000 by Pentel, but any pencil will do. Mechanical ones are better for finer detail.

MEDIUMS, PASTES, & GESSOS

• Gel medium such as Daler Rowney Impasto Gel for gluing collage materials. Avoid water-based glues for collage because they will dry out over the years and your collage may peel off.

• For acrylic transfers, you'll get best results with Golden Gel Medium, preferably soft matte.
• White gesso, such as Winsor & Newton, Liquitex, or Golden.
• Transparent or clear gesso such as Liquitex.
• Molding paste such as Golden, Liquitex, or Winsor & Newton.
• Crackle medium.

COLLAGE SUPPLIES

You'll need a variety of patterned scrapbooking papers, magazine pages, book pages, musical scores, and photos. I also often use washi tape as part of my collages.

TOOLS

• Brayer by Speedball.
• Palette knife, optional; you could also use an old plastic card.
• Craft knife by Stanley or X-ACTO.
• Scissors.
• Ruler.

 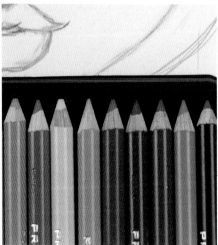

- Eraser.
- Heat gun or hair dryer.
- Brushes. I like Pro Arte Acrylix brushes, but any soft-haired firm brushes will do. Avoid brushes with coarse hair; you want soft but firm.

MARKERS & PENS

- Posca markers or Poster-Paint Sharpies in black and white, fine-nibbed and thicker nibbed.
- Tombow markers.
 - » SUBSTITUTES: *Any water-soluble, ink-based markers such as Aqua Markers by Letraset or Sakura markers.*
- Gel pens in metallic colors such as silver and gold.

INKS & SPRAYS

- Dylusions Ink Sprays. Start with a few.
- Daler Rowney FW Artists' Acrylic Ink.

STAMPING & STENCILING SUPPLIES

I use decorative rubber stamps and a selection of stencils. You'll also need waterproof ink pads such as StāzOn.

OTHER SUPPLIES

- Brass fasteners.
- Cotton swabs (Q-Tips).
- Gold leaf.
- Blending stump.
- Hole punch.
- Ribbons, string, yarn, and thread.
- Buttons, metal wire, and a small silver key (optional).
- Magazines, newspapers, and a printer
- Crystals (for Project 16, page 114).
- PanPastel artists' painting pastels, optional (for Project 9, page 62).
- Old plastic card.
- Found items from around the house, such as leftover tissue rolls, old kids toys, or cups for unusual stamping and mark-making.

NOTEBOOK

I recommend getting yourself a notebook—your Life Book Notebook—to write notes in if any ideas, feelings, or needs come up. You can also use it for the writing exercises described in this book.

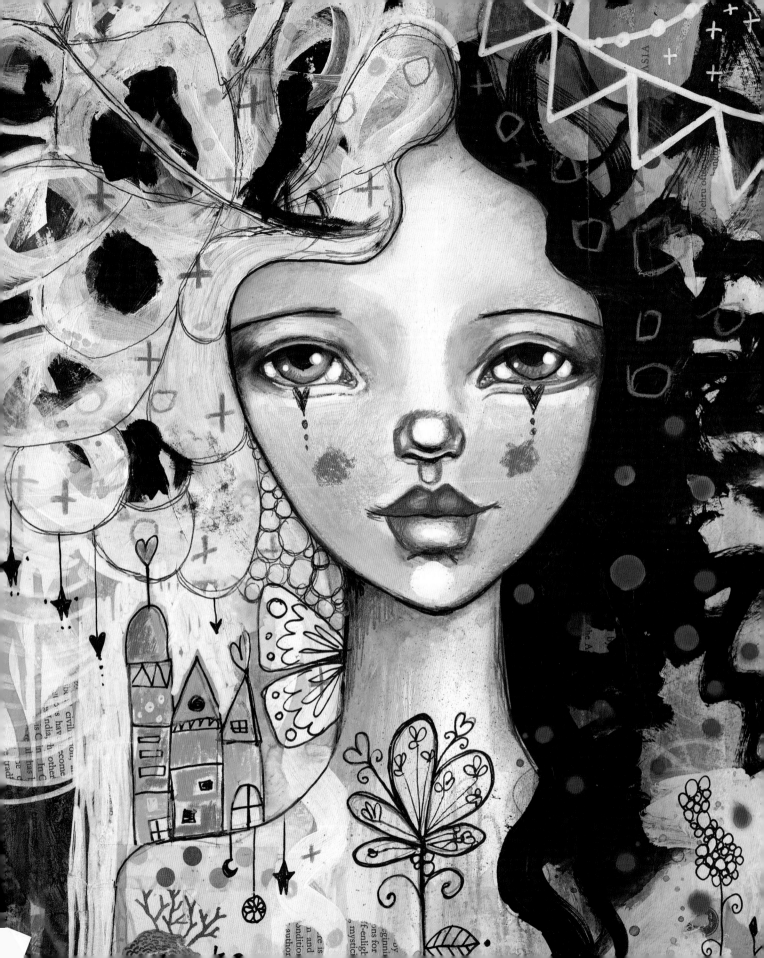

1
Letting Go, Manifesting & Celebrating

WE BEGIN OUR *CREATE YOUR LIFE BOOK* JOURNEY by taking time to create awareness around how we live our lives. Becoming aware of our behaviors, responses, and thought patterns can help bring us to a place of "choicefulness." Having choices means having more freedom to be, grow, and heal.

For the first few projects in this book, we look at what is and isn't working in our lives. To figure out what isn't working, we try to identify what's holding us back. These might include habits, limiting beliefs, fears, or relationships that might be stifling us or hindering our progress. We focus on letting go of those, and we also look at the behaviors, thought patterns, and relationships that are serving us and enriching our lives and spend time honoring and celebrating them.

Finally we consider what we want more of in our lives and how to enrich and enhance their quality. When we work on this topic, the manifestation of hopes and dreams is the focus.

Using the creative process, we work through these aspects of personal development and bring them to a point of transformation and loving resolution.

The Zen Butterfly

Let Go of What No Longer Serves You

AT THE BEGINNING OF A NEW YEAR, a new project, or a new phase of my life, I enjoy setting positive intentions. I like to look at things that help me navigate new beginnings with as much success as possible.

Exploration: Taking Stock of What's Holding You Back

As part of that process, I take the time to look at anything in my life that is holding me back and might be preventing me from succeeding in my next phase. I like to mindfully consider elements in my life that I am holding onto but are no longer serving me or that are stopping me from moving forward in positive and easy ways.

Once I've identified the things holding me back, I perform symbolic little rituals that help me let go of them. Stepping into this process mindfully and lovingly helps me honor and then release each item with love, giving me more freedom to focus positively, without anything holding me back, on my goals and intentions.

One of the rituals that helps me with this process is the creation of a Zen Butterfly, which I want to share with you in this chapter.

Before starting, think back to the previous year, phase in your life, or project and reflect on the following questions in your Life Book Notebook:

1. What did not go well?
2. What do you want to let go of?
3. What went well? What did you enjoy?
4. How and in what ways did you grow?
5. What do you want to take with you into the new year/phase/project?
6. What positive experiences or qualities do you want to call in more of?
7. What are your positive intentions about this year/phase/project?

let go of that which no longer serves you

Art Page: Zentangle Butterfly

For this project, you'll create a butterfly in a Zentangle style and incorporate a flight trail with writing on it that symbolizes you flying away from the things you want to let go of. The Zentangle style of drawing is meditative and can help you become more aware of and really focus on your positive intentions.

The butterfly is also flying toward the sun, which you'll fill with your positive intentions or things you want to call into your life.

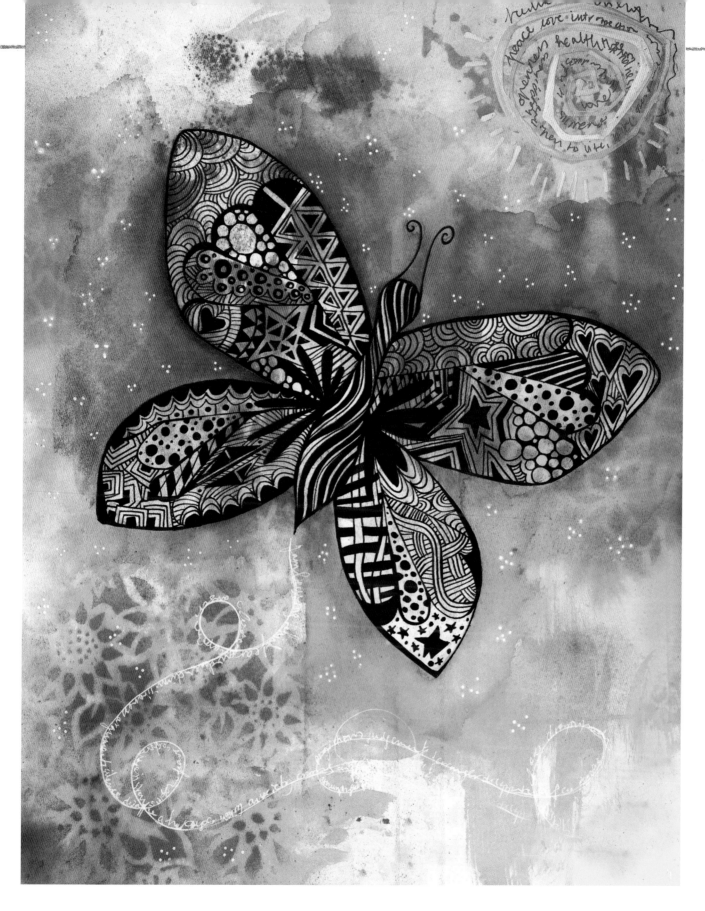

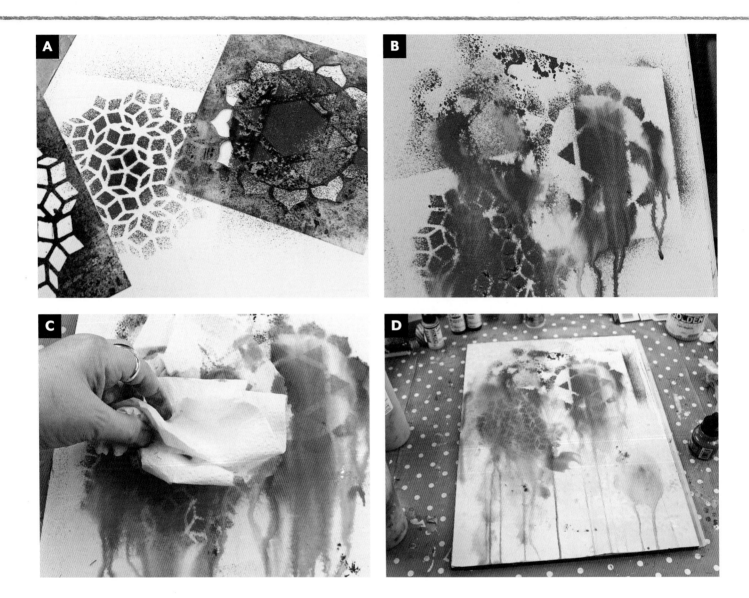

Create the Background

1. Using spray inks and your favorite stencils, create your first layer. Spray inks are wonderful to play with; they can be dripped, splattered, sprayed, and mixed. Let colors flower into each other and layer them over each other (**A**).

2. Add water to your inks so you can drip them, splash them, and splatter them around a bit. I like using small spray bottles with fine mist nozzles. Hold your page up to let the inks drip (**B**)!

3. Wipe away excess with a paper towel. The inks are very vibrant, so you won't lose much color, making your background too dark. Continue adding layers of inks with stencils, splashes, and/or drips (**C**).

4. I love adding acrylics inks for extra pop. In this case, I chose a bright orange that went well with my color scheme. Continue to drip and layer until you have a colorful background you love (**D**).

Draw & Tangle the Butterfly

1. Draw a simple butterfly shape onto your background. If you want symmetry, you could first draw it on a piece of paper, fold it through the middle of the butterfly, cut it out, and trace around it on the background. But if you don't care about symmetry, you can draw the butterfly straight onto the background by hand (**E**).

2. With a black pen, outline your butterfly (**F**).

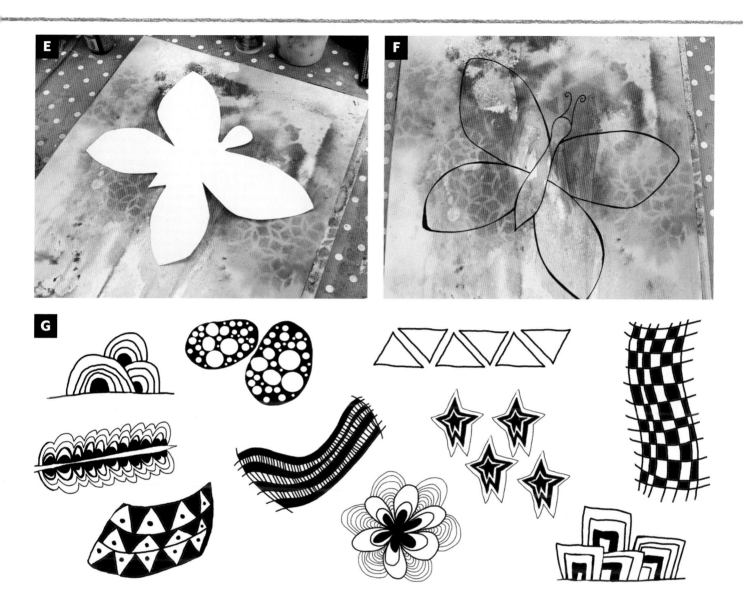

3. Next you'll start adding Zentangle shapes to your butterfly. This process can be meditative and relaxing. While you do this, focus your attention and/or meditate on the things you want to call into your life more and on your positive intentions. You can include the things you want to achieve and manifest in your life this year or during the new project you're working on. See **G** for some Zentangle shape ideas. Anything goes, really, so use your imagination to create new doodles and drawings. Repeat patterns and have fun!

Choosing Colors

Be careful to choose two or three colors that go well together. Avoid mixing them too much, as we don't want to create mud. When mixed, complementary colors—opposite colors on the color wheel—become neutral tones that may not be welcome on your page if you did not intend them.

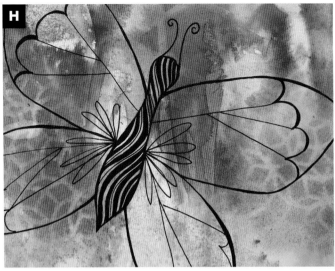

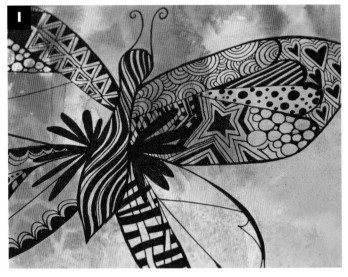

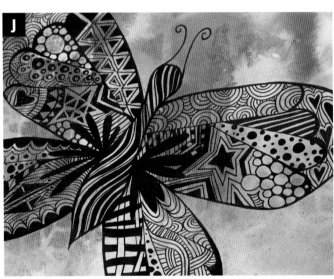

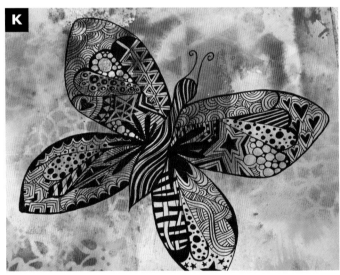

4. Continue to add Zentangles to all parts of the butterfly until it's filled up and you're happy with it, all the while meditating on the goals and intentions you want to fly toward (**H, I, J & K**).

Add Details for Letting Go

1. With a white or light-colored pen, draw a flight trail behind and underneath the butterfly. Write everything you want to leave behind you on that flight trail. The writing need not be legible; it's just for expressing all the things you're now ready to let go of (e.g., "I am letting go of fear, anger, sadness, resentment, etc."). You're using a light-colored pen because we want the trail and the things you let go of to fade away on the wind, symbolically speaking (**L**).

2. With a brighter color, draw a simple sun in the corner the butterfly is flying toward. I drew a spiral inside the sun so I could write my goals, intentions, wishes, hopes, and dreams in it. The butterfly is flying toward it, leaving a trail of all we want to let go of behind it (**M**).

3. For my final steps, I added ink around the butterfly to make it come off the background a bit more. This is an optional step; it depends on how immersed your butterfly feels in the background. If you want it to come forward somewhat, add some inky colors around it (**N**).

4. As a finishing touch, I added white dots to the background to liven up the page and to give the impression of spring pollen flying on the breeze (**O**).

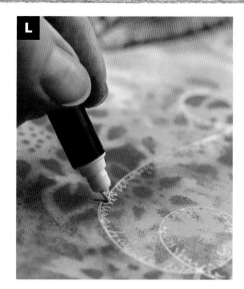

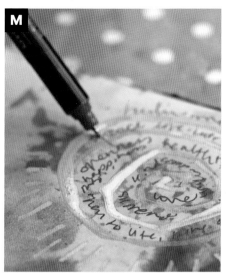

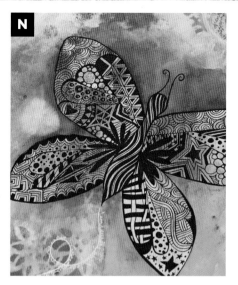

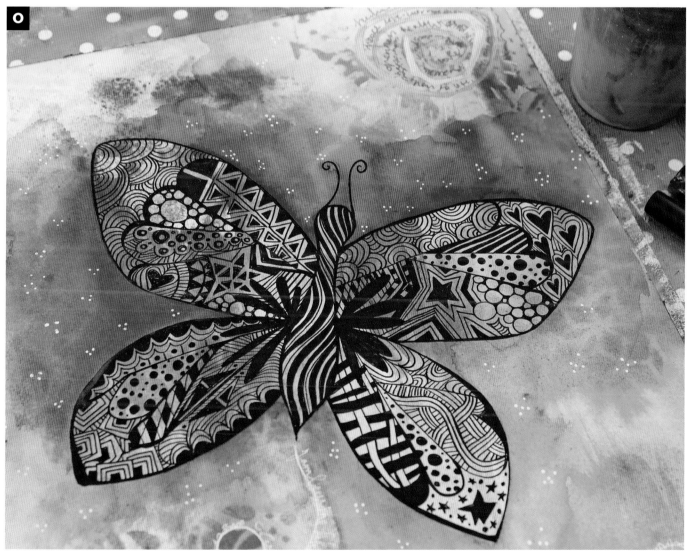

Envision Your World

Manifest Wishes & Hopes through a Dream Board

A DREAM BOARD—also called a vision board, a manifestation board, or an affirmation board—can help clarify and maintain focus to achieve a specific life goal, project, or dream. It's a tool that can serve as a visual representation of your hopes, needs, and ideal life.

You may be familiar with a traditional dream board that consists of words, images, and other elements cut out from magazines or newspapers and collaged on one surface. The idea is that if you display your board, see it daily, and dream about it, your goals and hopes for the future will be more easily and quickly manifested.

IMAGINE SURROUNDING YOURSELF WITH LOVE & LIGHT

The art page for this project features an image of you or one that represents you, which can evoke strong emotions as you work on it. Approach this step with love and care—as you might when looking after a beloved child—imagining that you're surrounded by love and light.

Exploration: Thinking into the Future

Though the intention of my dream board is like that of a traditional one, I take the concept a bit further. In addition to images of what I want (either collage images or my own drawings), I include a photo of myself as well as positive affirmations of my wishes and hopes. You can make a dream board at any time, but I love creating them at the beginning of a year or at the start of a new project to help manifest what I want for that year or for that particular project.

Because affirmations are most powerful and effective when they're in the present tense, they must be stated as if they're already true—for

example, "I am loved" as opposed to "I will find love." They also need to be personal, specific, and positive—"I am loved," rather than "I don't want to be unloved."

Before you begin, close your eyes, focus on the year or project ahead, and think about what you would like to manifest in your life. These could be physical things, such as a new car or house, or a new relationship or trip. You may also want to improve your health, become more self-loving, or find more community.

Write down your ideas for your dream board in your Life Book Notebook or on a separate piece of paper. You can also include little doodles, words, and notes. When you've written them all down, start your art page.

Art Page: Dream Board

This art page features acrylic transfers, which are great for creating distressed, vintage-looking images. Acrylic transfers can be done on paper as well as on surfaces such as wood or plastic. Because this technique creates mirror images of the print that's being transferred, start by using Photoshop or another photo-editing program to reverse/mirror your image before printing it out if you want it to look the same as the original.

For collage elements, you can use old book pages, musical scores, tissue, or origami or scrapbook papers—anything that inspires you. You can use either symbolic or literal images to represent your wishes and dreams. For example, if you want more time to travel, you may opt for a butterfly or

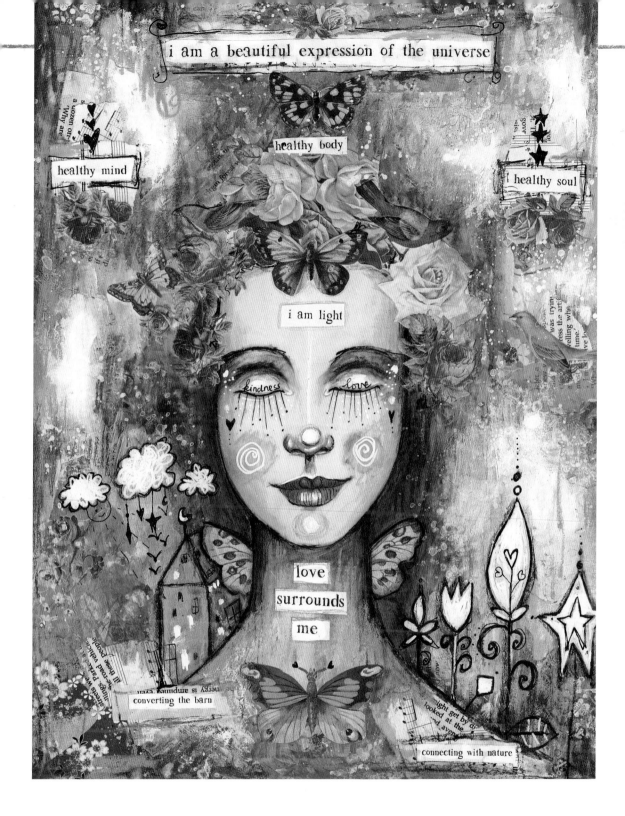

bird, or you can include images of the places you want to visit. Add other beautiful images to infuse your dream board with whatever will support and enhance the manifestation of your dreams and wishes. Also prepare printouts of your goal words, words of hope, and positive affirmations.

Transfer & Embellish the Main Image

1. Apply a thick layer of gel medium where you want to place your photo (or an image that represents you). Lay the image facedown on the medium. Use an old plastic card or other hard implement to smooth out any air bubbles (A).

2. Let it sit for 5 to 10 minutes and then brush water on the back. You'll start to see the image shine through (B).

3. Once the water has been absorbed by the paper, gently rub the paper off with your fingers to reveal the image absorbed by the gel medium (C).

4. Leave the image as is or draw and paint over it, enhancing and deepening lines. Add loving, affirming words and doodles that support what you want to manifest to the surrounding area (D).

5. Add shading and highlights if desired. I used crayons and markers to add subtle color to the cheeks and shaded areas. Follow the patterns of shading and highlights within your image or create completely new ones (E).

6. Add highlights with a white paint marker and dark accents or outlines with a black fine-point marker or paint marker (F).

7. Deepen the shading with colored pencils. To get a rich, smooth effect, sharpen your pencils and then lay the leads flat against the paper as you shade (G).

Collage the Background

1. Tear your collage papers and arrange the pieces in a pleasing way. Repeat and overlap them to create visual unity and relationships. Glue them down with gel medium (H). Use an old plastic card to smooth out any air bubbles.

2. Add meaningful images and your printed-out words to the face as a second

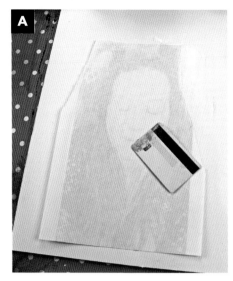
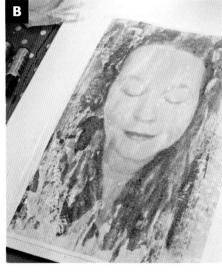

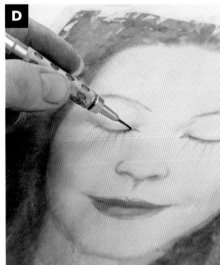
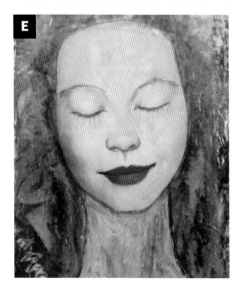
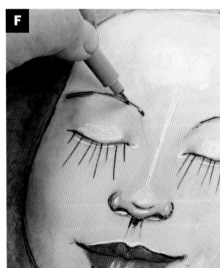

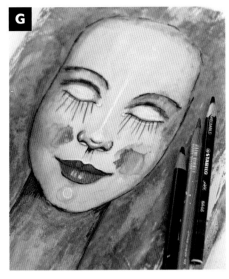

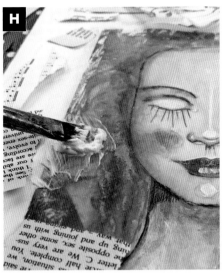

collage layer. Use pens and markers to enhance the face with additional details. Once the collage is dry, use water-soluble crayons to add a wash of color that lets the previous layers shine through (**I**).

3. If your background looks chaotic and messy, mute and unify it by applying a layer of white gesso with a brayer (**J**).

4. To create balance, harmony, and contrast, use markers, fluid acrylics, or water-soluble crayons to add concentrated patches of color (**K**).

5. Add simple drawings that represent your hopes and wishes. If desired, add collage images and affirming words wherever it feels right (**L**).

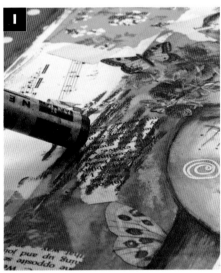

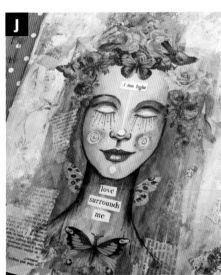

Finishing Touch

If desired, spatter the background with white ink, diluted white acrylics, or white gesso. Load a brush and gently tap it over the areas where you want the spatter to land.

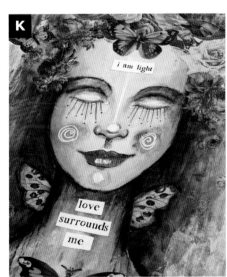

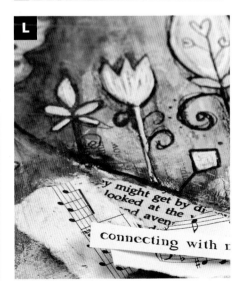

Layers of Your Heart

Celebrate & Honor the Loves in Your Life

GRATITUDE, HONORING, and celebration play big roles in my work, and I believe they contribute greatly to healing.

Just as we explore the things that don't work in our lives (see Project 1 on page 16), I believe it's incredibly important to look at the things, people, and elements in our lives that are working well. Which elements are having a positive impact on your life?

Exploration: The Happiness Triad

By celebrating and mindfully focusing on all the positive goodness and happiness in your life, you will attract more of the same. This exercise therefore supports the previous two projects. Celebrating and honoring what is going well in your life will help manifest more of the same and help you let go of what no longer works for you.

I call it the happiness triad:

1. Letting go of what no longer serves you.
2. Setting intentions and goals serving manifestation.
3. Celebrating and honoring what's working to cement and further deepen positive physical and emotional prosperity.

Art Page: Layers of Your Heart

In this project, we will create a heart deck or heart flower (showing the layers of your heart) on a page that contains a concertina envelope to house it. We'll use different mixed-media techniques to decorate each heart to celebrate a positive element in your life. You can celebrate people, animals, achievements,

positive experiences, inanimate objects, or other more abstract concepts. They can be big things (e.g., "I graduated") or little things (e.g., "I saw a beautiful butterfly today"). Make a list of whatever you feel is working well in your life or is making a positive contribution to your happiness in your Life Book Notebook or on a piece of paper. Let's get started!

"the more you praise and celebrate your life, the more there is in life to celebrate."

—oprah winfrey

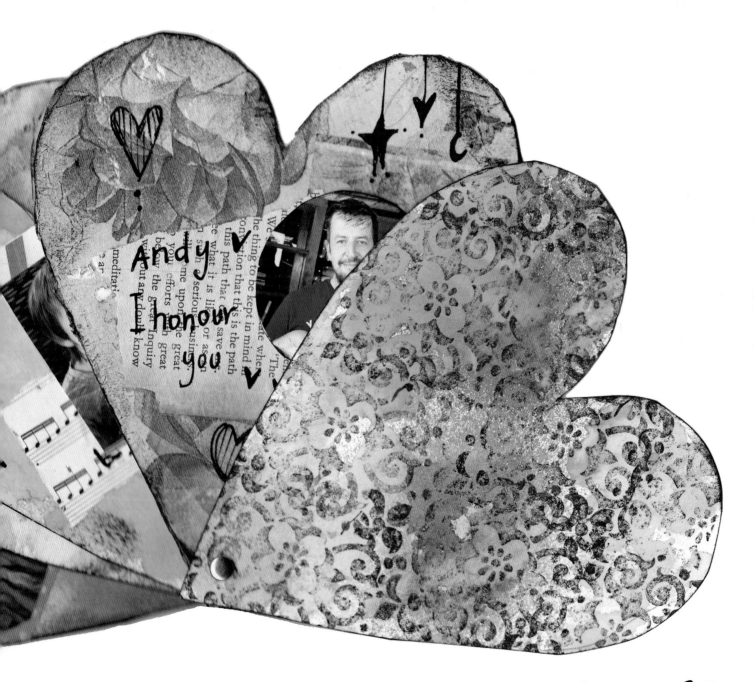

Create Your Hearts

Draw six or seven hearts on 140 lb (300 g/m²) watercolor paper and cut them out. I worked on 9 x 12 inch (23 x 30.5 cm) paper, and my hearts were approximately 5½ inches (14 cm) tall. You can choose to have different sized hearts or make them all the same. In my heart deck, all the hearts are the same size; I simply traced around the ones I had done previously. You can draw one by hand first, cut it out, and trace it (**A**).

Decorate Your Hearts

When I make these heart decks, I like to decorate the hearts in very different ways so they contrast but still complement each other. Each heart will represent a positive element you'll celebrate in your life. Here are some decorating ideas I used:

1. Using ink sprays, apply light washes to some of your hearts and/or combine washes with stencils. As the inks are very reactive to water, it's best to use colors that mix well together. Avoid complementary colors (**B & C**).

2. If you don't have ink sprays, you could dab some heavy body acrylic paints or gesso through stencils. The imagery won't be as crisp, but you can create a nice texture with it and your stencil will show up differently from spray inks (**D**). Here you can see spray inks next to acrylics both applied through a stencil. Mix it up if you like; nothing is too wild. Follow your joy! Be playful and experimental (**E**). Be sure to include the back of your hearts when you decorate, as they will also be visible.

Tip

If you don't want your hearts to buckle, wet the back of your paper too.

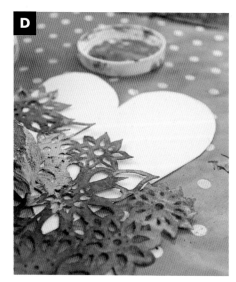

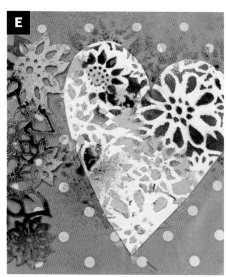

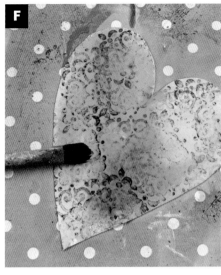

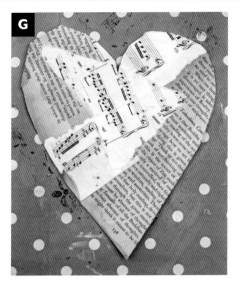

3. Using a waterproof ink pad and a pattern stamp, apply a layer of stamping to one of your hearts. Then spray or paint two colors over the stamped layer (**F**).

4. Add vintage collage or book pages to your heart (**G**).

5. Use a variety of washi tapes to decorate your heart (**H**).

6. Patterned napkins are a great addition to any background or layer. The first layer of napkin (be sure to peel off the other two layers) will dry transparent if applied with matte medium (**I**).

7. The possibilities are endless when it comes to decorating your hearts. I'm sharing some decorating ideas with you, but please do not limit yourself only to my suggestions. Go wild, think outside the box, and do whatever calls you! Here is a group of decorated hearts together (**J**).

Add a Dark Ink Edge

1. Before adding your celebration elements to your heart, use an ink pad to add shadow to the borders (**K**). It gives them a little more dimension.

2. Once all your hearts are finished, take a moment to refer to the list of things you are grateful for and that you want to celebrate.

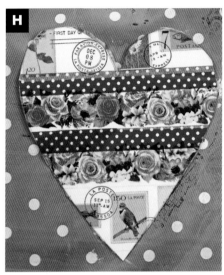

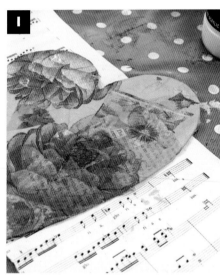

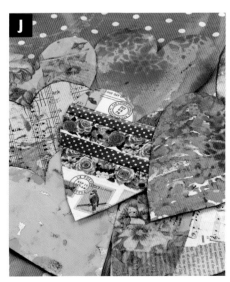

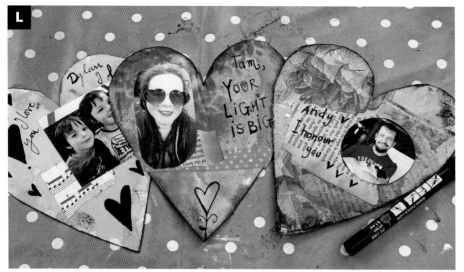

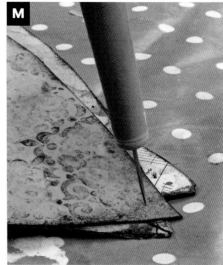

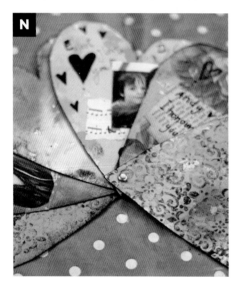

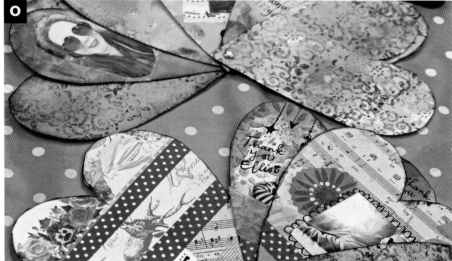

Add Celebration Elements

The options are equally endless when it comes to adding your gratitude elements to your hearts. Feel free to experiment and explore how you want to add your celebrations to your hearts. Here are some celebration ideas I used (**L**).

1. Print out photos of your loved ones and add them to the hearts. You can doodle and draw on and around the photos too. I like adding crowns, hats, hearts, stars, and the like.

2. Add messages of gratitude, love, and/or celebration around the photos.

3. Add lists of gratitude to your hearts.

4. Go for simplicity and emphasis by just writing one name, thing, element, animal, or pet on a heart.

5. Write your gratitude along the edge of the heart.

6. Add quotes, lyrics, or inspiring prose about celebration from poets, authors, or singer-songwriters you love.

Put Your Booklet Together

1. Once you've finished all your hearts, you're ready to put your deck together. Using an awl or pin, prick holes in the bottoms of the hearts and push all the hearts onto a brass fastener. Once all your hearts are on, pry the two stalks apart and push them down (**M & N**).

2. You can make more than one deck (**O**).

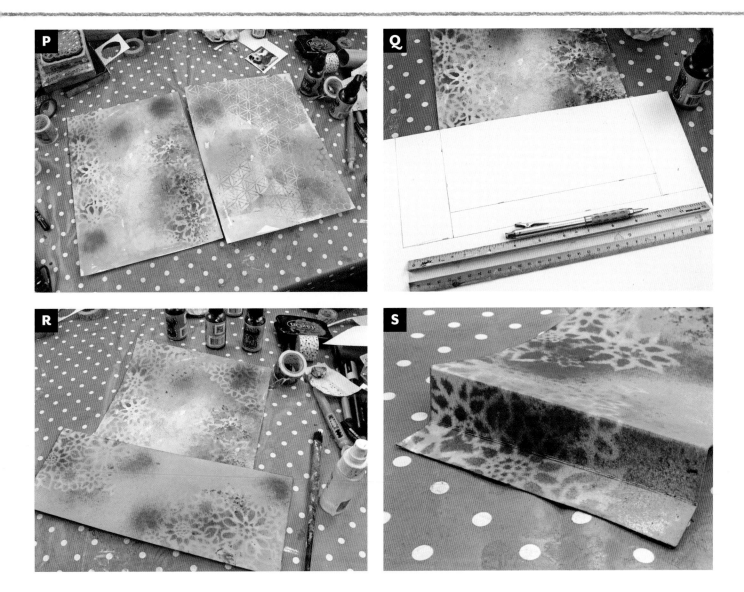

Put Your Page & Envelope Together

1. You'll need two pieces of watercolor paper to create your page and envelope. For the main page, I used a simple background technique like the one done on one of the hearts. I applied a wash with ink sprays (two colors), added water with a brush, and then added some stencils for fun effects (**P**).

2. If you want the hearts to peek out of the envelope when they're slotted into it, be sure to create the envelope at about one third of the original page size. Make the height approximately one third of your original page plus approximately ½ inch (1 cm). Then add 2 inches (5 cm) on each side lengthwise. Cut it out (**Q**).

3. Before folding your envelope, decorate it the way you want. I wanted it to match the main page, but you could choose to decorate yours differently (**R**).

4. For ease, wet the back of your envelope; it will make the paper more pliable. Now fold the bottom of the envelope in at the ½-inch (1 cm) mark. I added lines so I knew where to fold. Use a bone folder or a hard implement to sharpen your fold. Now on both side edges, fold in on the 2-inch (5 cm) mark. Fold the edges back in on themselves (midway) as if to create a fan shape (**S**).

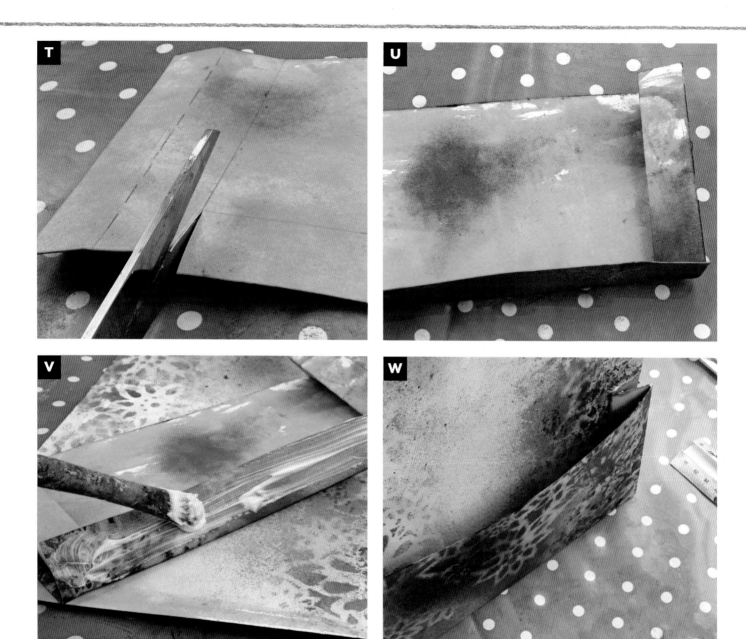

5. Cut off the bottom part of both folded sides that overlap with the bottom fold (**T**).

6. You'll need to end up with this shape (**U**).

7. Once you fold everything in, place the sides in first. Glue the bottom onto the outside of the two outer sides.

8. When your envelope is folded, glue it in place with a strong (heavy body) gel medium (**V**).

9. To fortify it, I also added washi tape to make sure it wouldn't come undone (**W**).

10. As a final touch, I drew doodles in the top right corner. I liked the background pretty much as it was, but it needed something there (**X**).

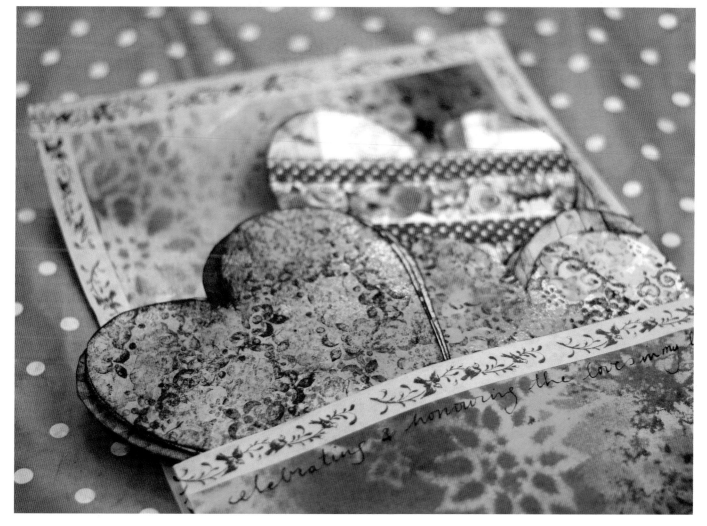

X

Following the Light

Engage in Meditative Painting

CONTRIBUTING ARTIST ALENA HENNESSY

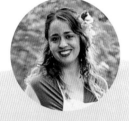

Meet Alena Hennessy

Alena's work has a deeply spiritual element to it. Her work and lessons often take me into other worlds where my mind can wander and my deeper, inner light and intuition can come forth to "do the talking," so to speak. Alena's gentle, sensitive, and expressive ways of being in the world are a huge inspiration to me. In this project, she guides us on a meditative creative journey that will get you in touch with your deeper, truer self, bringing clarity and self-connection.

IN THE PAINTING SHOWN opposite, I explored expressing light in abstract and symbolic ways. Not only did I create layers of paint to show the elusive and ever-changing qualities of light, but I also added actual gold leaf, which adds a highly reflective quality to the works. I was also interested in creating works with the intentional energy of "I am." In other words, what lies at our true essence? Invoking a feeling of the mystery and the depth of our existence is of much interest to me, as is the perpetual changing nature of reality. The delicate leaf forms in the square painting are representative of the fragility of existence. To me, in the end, they create a feeling of celebration and gratitude that every day is indeed a gift.

Exploration: Finding Your Center

1. Meditation. To begin painting in this fashion, allow yourself to take 15 minutes to close your eyes and breathe deep into your belly. Allow your breath to move up and down your torso, even sending breath and energy all the way down into your toes and up to the crown of your head. Feel the stillness within yourself and listen to your heart. What does it have to share with you now? Alternatively, you can take a quiet walk in your neighborhood or park, simply noticing, or stare out a window and begin to take in all that you see in an objective fashion. Giving yourself time to feel where you are and what your body, heart, and mind are communicating to you is a valuable step in intuitive and intentional art-making. When you close your eyes, what shades of light and shadow do you see? How does light illuminate your world in your daily life? What does the gift of light give?

2. Reflection. After taking time to center or meditate, reflect on the feeling of "I am." How would you answer the question? Begin to write in a free-flowing fashion or stream of consciousness without censoring yourself. What is at the core of your essence? Write for 10 to 15 minutes in this way. At the end of your entry, write out the words "I am _____ " five or so times. Fill in the blanks with what comes to you first. Some examples could be:

- I am light (and shadow).
- I am unbridled joy.
- I am a spectrum of colors.
- I am infinite.
- I am breath, spirit, emotion, and thought.

Art Page: Following the Light

I paint in an instinctual style, a process in which I "feel my way" by responding to each mark made. Working with India and acrylic inks, along with acrylic paint and water-based paint pens, gives the works layers

of depth. Water is an important element in my work, as I wish to have the free-form expression of fluidity shown, so I add a lot of water to the ink and layers of acrylic. Adding the sheets of gold leaf to these paintings gave them an extra layer to invoke actual reflective life. The piece above is an alternate outcome using the same process used in this project.

"beauty is not in the face; beauty is a light in the heart."

—kahlil gibran

1. Choose a substrate to work on (I like wood panel or Aquabord, but watercolor paper is also nice) and wet the surface with water. Spread India or acrylic inks, just a few colors, around in fluid, circular motions. Choose colors that reflect your current mood. Warm colors (reds, oranges, and yellows) are vibrant, give energy, and are passionate and active. Cool colors (blues, greens, and purples) are calming, recede, are at times melancholy, and give space (**A**).

2. Keep the layering process going with inks until it feels satisfying to you. Allow the water to work its magic and create feathering, drips, and fluid organic movements. Once the background is dry, you can add and blend a few acrylic colors. Keep layering and creating movements in different directions (**B**).

3. Let the surface dry. Use colored pencils to add drawings if desired. I drew a small boat with little pennants and swirling clouds above it (**C**).

4. If you wish to add gold leaf, read the package directions on how to apply it. It is pretty self-explanatory; you usually need to add the adhesive and let it sit for 25 minutes until it becomes tacky and then add the gold leaf sheet, pressing it down with your fingers and removing excess. I decorated my boat and its flags with gold leaf (**D**).

5. Once everything is totally dry, add details and imagery that speak to you with water-based paint pens. I like to feel my way through the paint, and this practice takes time (**E**). After adding details with the pens, you can also go back and add more ink or paint: layer, layer, layer!

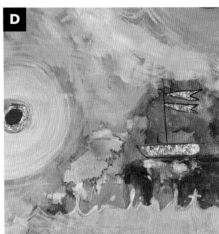
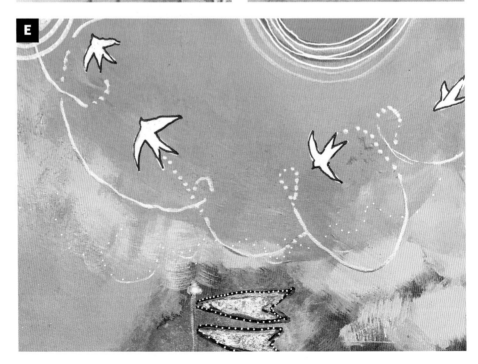

With practice, you'll begin to find your voice with painting. Try creating these paintings with at least five layers!

Remember that acceptance of where you are as an artist and what comes through you in the moment is the most important thing. Keep allowing your creativity to unfold unhindered, and you'll receive immense benefit from it.

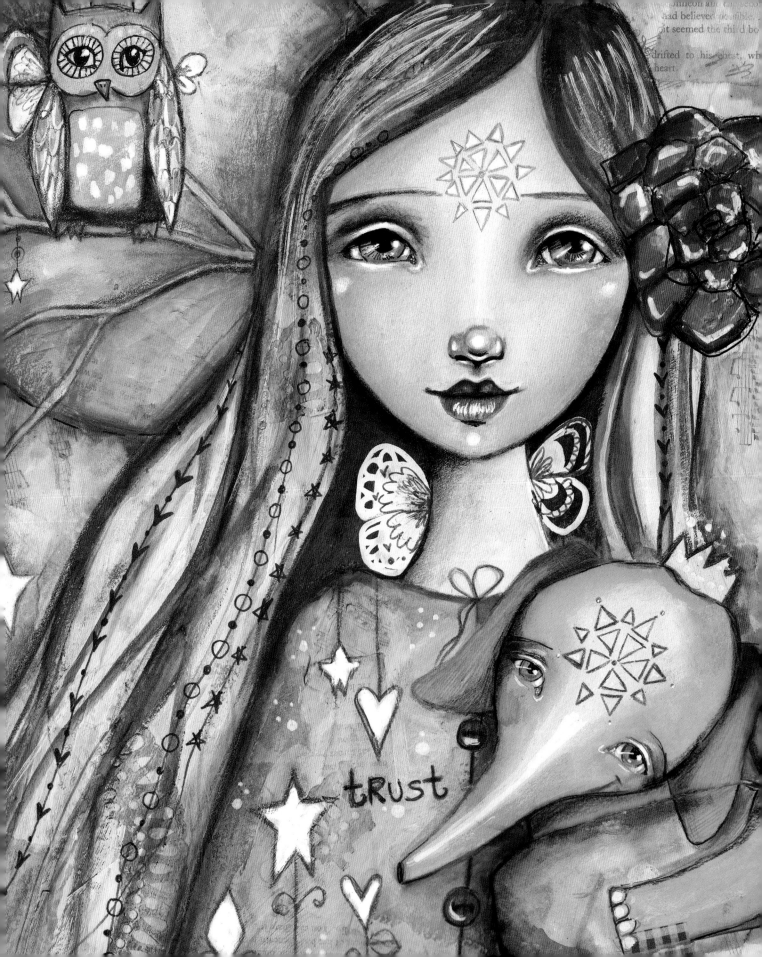

2
Self-Love, Grounding & Being Present

AS WE CONTINUE OUR *CREATE YOUR LIFE BOOK* JOURNEY, we start to look at how we can embrace our unique, quirky selves, including our light and dark parts. We then use this understanding to grow our practice of personal acceptance and self-love. We'll finish with an intuitive honoring of this newly-known you!

This chapter begins with a freewheeling grab at our uniqueness—"No One Alive . . . is Youer Than You!" From this place of open self-acceptance, we delve more deeply into ourselves, getting closer to our more self in the present. Then with a slice of magic, we let this whole-self awareness, our emotions, our feelings, and our needs be our guide. In this way, we learn to play, be spontaneous, and trust the journey of our inner experiences.

Overall this chapter shows how embracing our whole selves fully through a lens of feeling and needs builds our intuition and self-understanding and grows self-love. This is honored in the final project.

"No One Alive . . . Is Youer Than You!"

Embrace & Love Your Inner Quirky Bird

SOMETHING THAT HELPS ME CULTIVATE happiness and contentment in life is being less judgmental and more accepting of myself, including my more unusual and quirky personality traits.

We're often taught that we're not good enough and told we must change things about ourselves to be acceptable to others. I personally think this is harmful to people's self-worth and self-esteem. I'm no longer interested in pursuing some sort of elusive definition of perfection, and I have decided to embrace all my quirky and weird personality traits! I'll tell you, it's a huge relief, and it brings freedom to be at peace with yourself.

So, instead of feeling ashamed of the fact that we love to sing in the shower, we wear bright purple clothing, we talk to ourselves, or we are *Star Wars* geeks, I encourage you to embrace all your quirky traits by embodying them in one of my signature Quirky Birds.

Exploration: Taking a Quirky Traits Inventory

Take a moment to think of yourself and any traits that you might consider quirky. Write them down in your notebook. Consider what symbols might represent your quirks. Some examples: If you sing in the shower, you could use a musical note. If you wear bright purple clothing, you could use purple on your bird. If you consider yourself a dinosaur geek, you could use a little dinosaur as a symbol. If you're obsessed with ballet, you could dress your bird in a tutu. If you consider yourself a book worm, you could use eyeglasses as a symbol. Whatever symbol you associate with your quirk(s) will suffice. These symbols will be added to your Quirky Bird later.

For this project, my quirks are singing in the shower and amusing myself by telling my children, "I'm the queen of all unicorns." (They're seven and five years old, and they find it hysterical.) I'm going to symbolize that by giving my bird a crown in my art page.

Art Page: Quirky Birds

These little birds are easy to make, elicit great joy, and can help you accept you for who you are, flaws and all. Quirky Birds are deliberately created

"today you are you! that is truer than true! there is no one alive who is youer than you!"

—dr. seuss

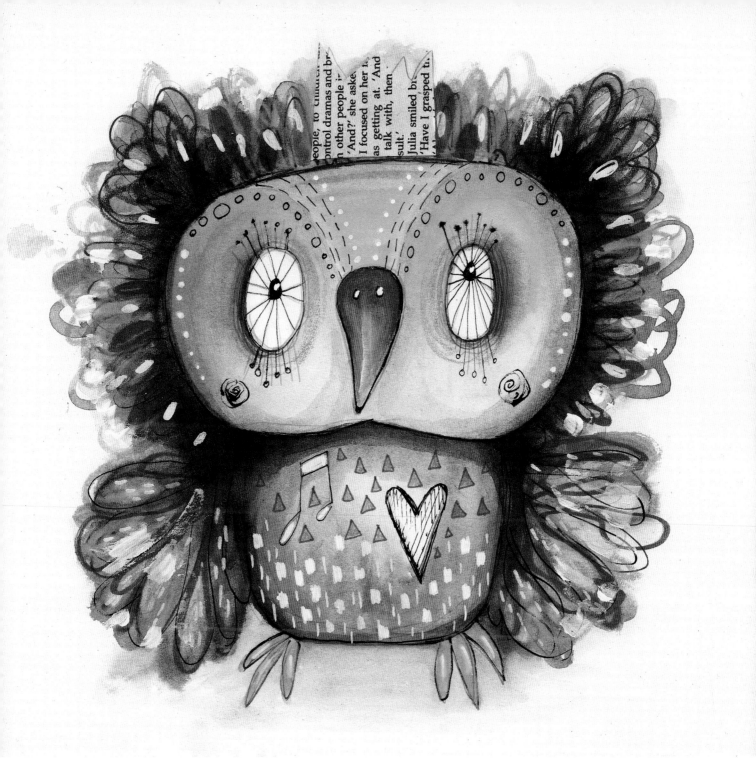

somewhat asymmetrically to represent that we all have flaws and quirky traits that make us, us. They are here to remind you that you are wonderful just as you are. Join me in making your own Quirky Bird as a reminder to always accept yourself wholly and fully, including your unique quirky traits!

Sketch Your Quirky Bird

Draw a simple yet asymmetrically shaped head and body. Add some feathers in places you want them and draw the eyes and the beak (**A**). Don't worry about perfection (none of us is perfect!). Approach this with childlike joy!

I recommend that you do some sketching before you start your "real" painting/illustration. There are many ways to create this bird, and sketching beforehand can get you in the mood. It will help you get used to letting your inner child play and unfocus on perfection. Sketch away, get yourself familiar, create an overall design, and then start on your main painting/illustration.

Add Color

Once you've sketched your bird, including its symbols (I added a heart and a musical note to its tummy), add color. Don't worry about realism. Choose colors that call to you or symbolize your quirks. I used water-soluble crayons and markers alternately, adding layers and working wet-in-wet to let colors bleed into each other. Don't focus on making a perfect painting; focus on joy, fun, and the capturing of and embracing of flaws and quirks (**B & C**).

Add Definition, Shading & Details

1. Use a black pen to add definition to the eyes and beak. I like to use black pen to add quirky or wonky details to the face, feathers, and tummy too (**D**).

2. Continue adding layers of colors as desired. I added shading in the areas where you might expect darker shading, such as under the head/neck area, on the outer edges of the body/tummy, and in the creases of the wings (**E**).

3. Add quirky little details such as oddly shaped circles, eyelashes, dashes, and so on to the face and/or other areas (**F**).

4. Add line work to the feathers and symbols on the tummy (or elsewhere) (**G**).

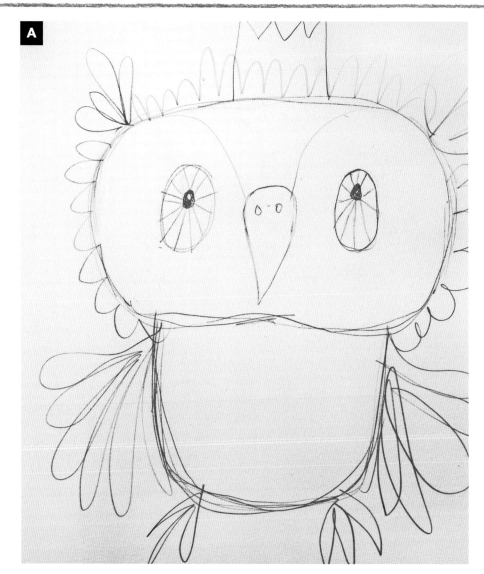

Characteristics of a Quirky Bird

- *Asymmetry (asymmetrical eyes and/or wings)*
- *Wonkiness (beaks, wings, legs)*
- *Oddness (add odd clothing, hats, pants, waistcoats, tutus, etc.)*
- *Funniness, sweetness, and/or childlike shapes*
- *Bright colors*
- *Tiny doodle details (draw your unevenly)*
- *Unrealistic*
- *Fantasy-like*
- *Imperfect; deliberately a bit wrong (which adds charm)*

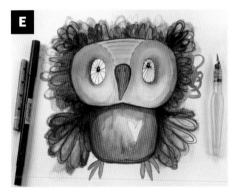

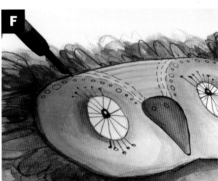

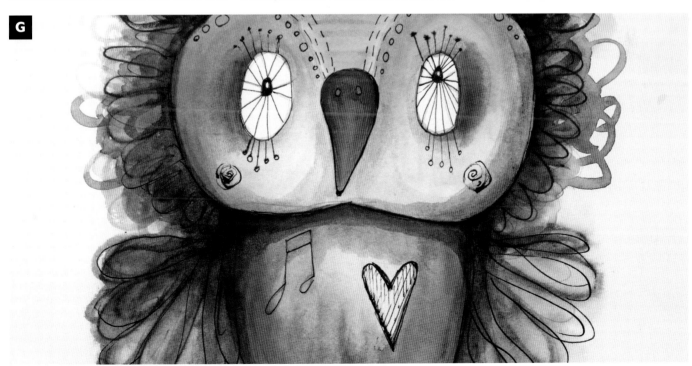

5. Enhance the shading if it speaks to you (**H**).

6. I also like adding additional doodles, details, and quirky shapes with a white pen for contrast (**I**).

7. I added a crown cut out of book pages to symbolize my quirky trait of telling my kids, "I'm the queen of all unicorns" (**J**).

8. If desired, add one more layer of color with water-soluble markers and/or crayons (**K**).

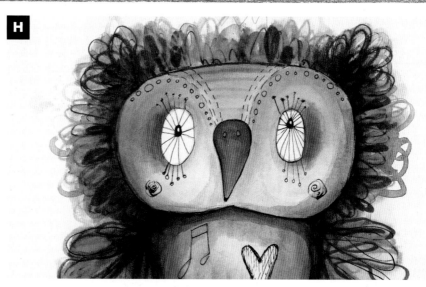

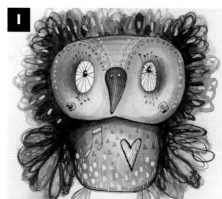

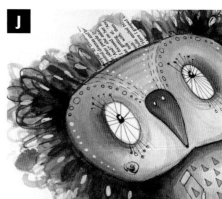

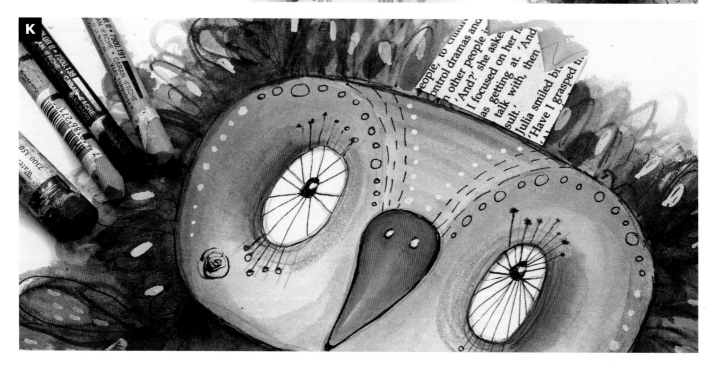

A Flock of Quirky Birds

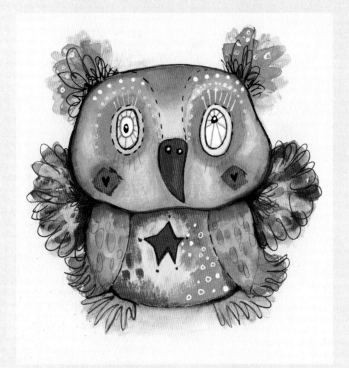

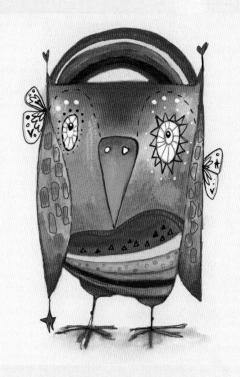

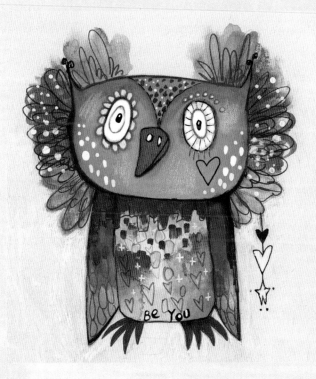

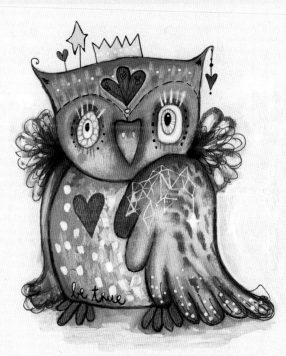

Looking Inward

Be Present to the Wholeness & Fullness of You

AN IMPORTANT PART of the path toward more self-acceptance and self-love is cultivating the ability and courage to become aware of and be present to all that goes on inside of you, not just the happy feelings. Many of us have learned to repress, reject, or ignore negative feelings such as sadness, anger, and pain. In this project, I'll encourage you to spend some time quietly in meditation, scanning your body and noticing your feelings and sensations.

Exploration: Observing & Acknowledging Your Feelings

While you meditate for about 5 minutes or so, breathe deeply and imagine a gold cord coming out of your spine and going into the earth, anchoring you there. This will help ground you into the present moment and into your body. Then focus on your body, simply honoring and witnessing or being present to the feelings and sensations inside of you. Anger, pain, happiness, sadness, joy, blahness, nothingness—whatever is there, notice it and honor it. Go slowly. Whatever you notice, don't judge it or try to fix it. Just allow it to be. Sometimes the feeling may want to tell you something: listen, notice, and honor.

Simply honoring, giving voice to, and/or noticing the feelings, needs, and thoughts inside of you can be very cathartic and healing. Often feelings just need to be heard so that they can move on again. When we ignore, repress, or neglect our inner world, feelings can often get louder, and if we keep repressing and ignoring them, we can start to create

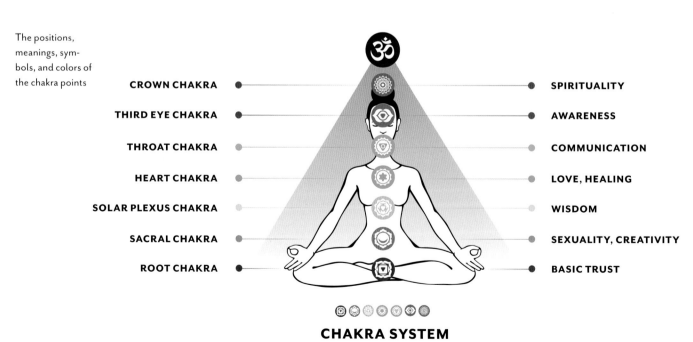

The positions, meanings, symbols, and colors of the chakra points

CROWN CHAKRA — SPIRITUALITY

THIRD EYE CHAKRA — AWARENESS

THROAT CHAKRA — COMMUNICATION

HEART CHAKRA — LOVE, HEALING

SOLAR PLEXUS CHAKRA — WISDOM

SACRAL CHAKRA — SEXUALITY, CREATIVITY

ROOT CHAKRA — BASIC TRUST

CHAKRA SYSTEM

other problems. Simply listening and saying hello to what is alive in you can work healing miracles.

Once you've finished your body scan during meditation, take some time afterward to write down what sensations you noticed in your body and where they were. For example: "I felt some tightness in my chest"; "I had a headache"; or even "I needed to pee!" Whatever you noticed, write it down.

Art Page: Meditation Girl

Now we'll create a painting that includes a little Meditation (or Chakra) Girl. For this project, I've drawn chakra symbols on the body of the meditating girl corresponding to the feelings I sensed in my body when I meditated. This painting represents an honoring of the sensations in my body. I also called upon any chakras that were blocked to open, by drawing the chakra symbols in the places where I felt painful sensations. If you felt happy or positive sensations, you can still draw chakra symbols on the corresponding chakra points to encourage further unblocking or opening or simply as an honoring.

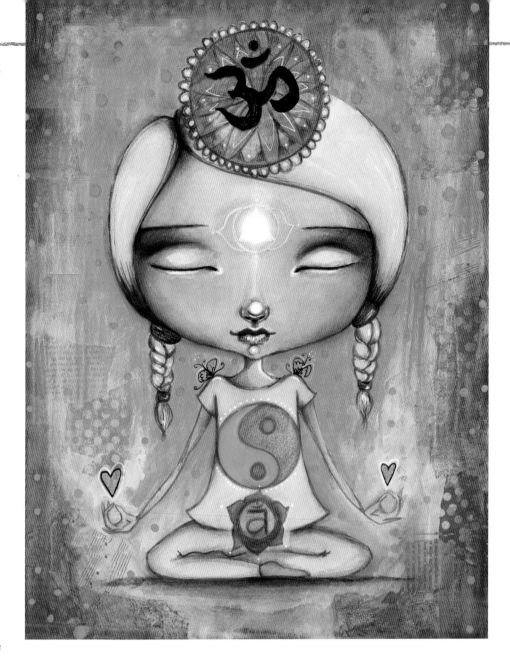

honor what is alive in you

Draw Your Meditation Girl

1. Sketch out the basic shapes of the head, torso, and legs, as well as the position and basic shapes of the arms (**A**).

2. Sketch in the basic shape of the shirt (**B**).

3. Divide the head following the proportions shown to add the features of the face (**C**).

4. Develop the positioning of the hands and fingers (**D**).

5. Add the hair and the details of the clothing and legs. Erase the penciled sketch guidelines (**E**).

Paint Your Meditation Girl

1. I like to start my light-skinned girls with a salmon crayon skin tone and then often use an acrylic paint in a similar tone as a second layer (**F**). For darker skin tones, start with salmon or ochre and build up the color with oranges, reds, and browns.

2. I add details to the face and hair with crayons, colored pencils, and markers (**G**).

3. Build up darker shading and finalize the clothing. I added in the yin and yang symbol to honor the light in the dark and the dark in the light (giving presence to all that lives within us, not just dark or light) (**H**).

Collage the Background

1. Add collage to the background with gel medium (**I**). Let dry.

2. Add color with crayons or watercolor paints (**J**).

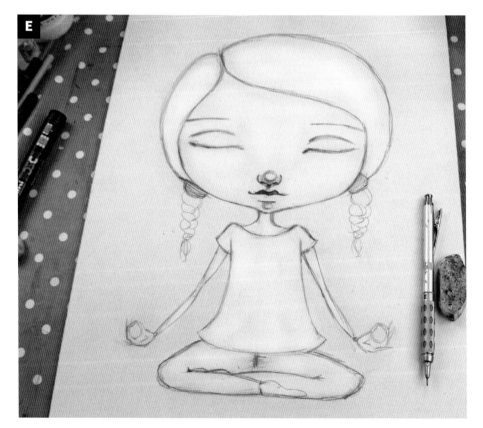

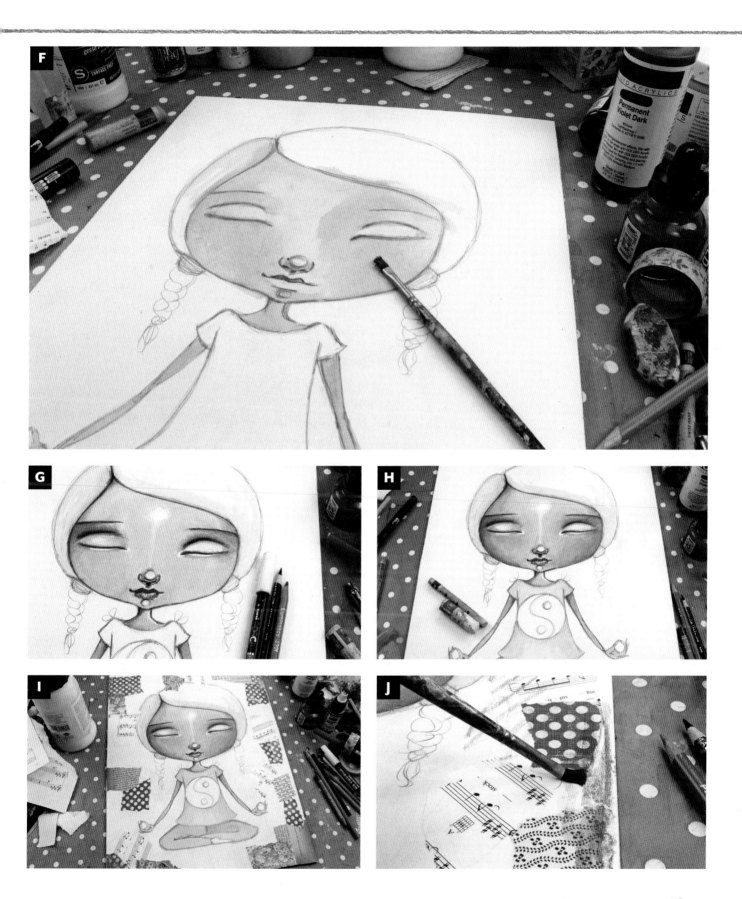

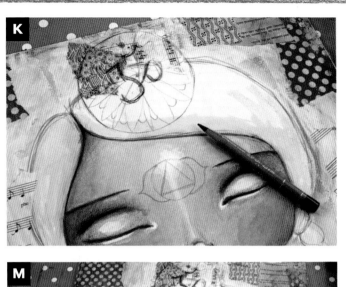

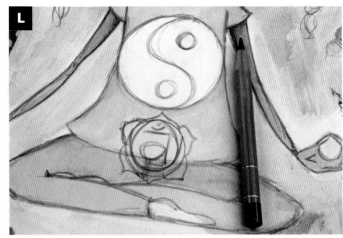

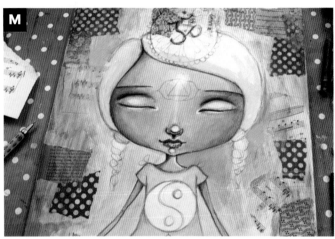

your feelings are
sacred & holy

Add the Chakra Symbols

With a dark colored pencil, draw chakra symbols corresponding to the sensations you honored earlier in your meditation. In addition to the yin and yang symbol on the shirt, I also chose the crown chakra, the third eye chakra, and the sacral chakra (**K & L**).

Develop the Background

Continue working on your background by adding more intense and intentional color blocks and white gesso, using a brayer to unify the layers (**M & N**).

Finishing Touches

1. I enhanced and intensified my chakra symbols with markers and pencils (**O & P**).

2. With a black pen, I added little doodles and dark accents where needed (**Q**).

3. As a final touch, I added orange dots to the background for extra sparkle and pop (**R**).

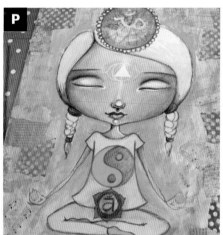

Seeds of Love

Let Your Emotions, Feelings & Needs Guide You

TO FURTHER CEMENT THE PROCESS of getting more intimately connected to yourself, I encourage you to get in touch with your intuition and gut instinct. This is helpful for both the creative process and your personal development and growth.

Intuition can be an elusive thing to some. Depending on how you were raised, you may have learned to ignore the subtler signs of your body and intuition and rely much more on your head. I am one of those people! But over the years, with meditation, focusing, mindfulness practices, and presence work, I'm more in touch with my intuition and gut instinct now than I ever have been before.

It's a wonderful feeling when we can get in touch with that part of ourselves that seems to have a deeper knowing. I daresay our intuition is often wiser than our minds! That said, I'm not trying to knock the mind; it's been my friend for many, many years. You want a nice balance of both.

Exploration: Listening to Your Intuition

To begin, take a moment to become still, grounded, and aware of any feelings or sensations in your body. Take deep breaths and start to focus your attention on your body and emotions. Notice any feelings inside your body, either emotional or physical. They could be happy, sad, light, or dark; you might notice discomfort, pain, contentment, joy, or the like. Try not to judge the feelings and sensations; simply notice them and be with them. Just acknowledge what is right now.

Art Page: Seeds of Love

For this project, I encourage you to listen to your intuition and respond to your gut instincts when creating your piece of art. For someone like me, who always needs to work mindfully on relinquishing control, it's wonderful to ease the pressure, be much

Color Scheme Suggestions

less directive or controlling, and just ask myself, "What wants to happen next?" I then respond intuitively to my page, to my supplies, and to my inner world. I just let the creative process take me where it wants to go. Sound scary? That's okay and understandable. For some, it can be a bit of leap to jump in without a grand plan in mind. But one of the most amazing things about creating (and life; they are often a mirror of each other) is that when you focus on the journey, the playfulness, and the joy of creating and less on the outcome, you often create paintings that have a joyful spontaneity and beauty to them. That beauty is much harder to achieve than something you planned out to a T. This process can be a very liberating, healing, and freeing experience. I hope you love doing it!

If you feel a bit intimidated by just starting with nothing in mind and you want to have something to hold onto, I'd suggest you pick a color scheme ahead of time and let both your intuition and your color scheme lead you (see opposite for examples). This is an optional step in case you want some idea beforehand. If you want your colors to emerge intuitively, absolutely go ahead and let them!

Though I describe the series of techniques I chose intuitively while creating my painting, above, you don't have to follow them. In fact, I encourage you to listen to your own intuition and follow it closely. Lay out a variety of materials and supplies within arm's reach so you can easily grab them and do what feels good to you. Follow *your* joy, *your* bliss, and *your* steps. This will help you to get in

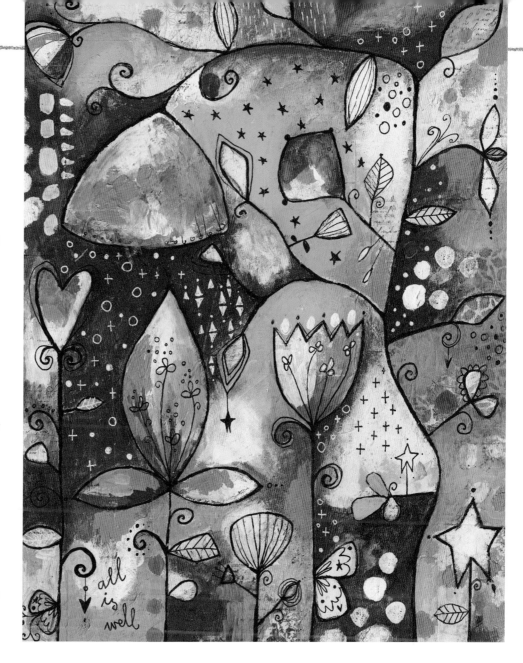

touch with your own feelings, needs, tendencies, emotions, and/or inclinations. You'll get more in touch with what scares you and what delights you, which colors really speak to you, and which colors you like to avoid. Consider this project a playful exploration of what *you* are all about.

1. I started writing down any sensations, thoughts, and emotions that were present for me at that moment (**A**). I love this step because it feels cathartic, expressive, and self-loving. In between each layer, ask yourself, "What do I feel like now? What do I want to do now?" Respond to what you feel.

2. I then added collage scraps that called to me using gel medium (**B**).

3. At this point, I felt inspired to add color blocks with crayons and activated them with water (**C**). If you're a more experienced artist, you'll find that you may fall into your usual patterns. That's okay; just keep responding to what wants to come forth.

4. To unify the layer, I added white gesso with a brayer (**D**).

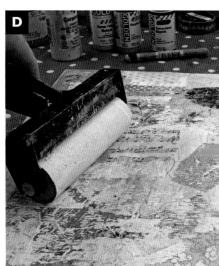

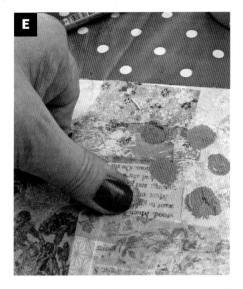

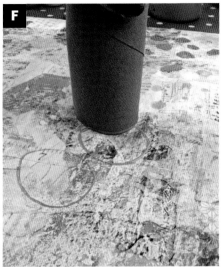

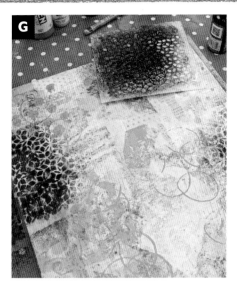

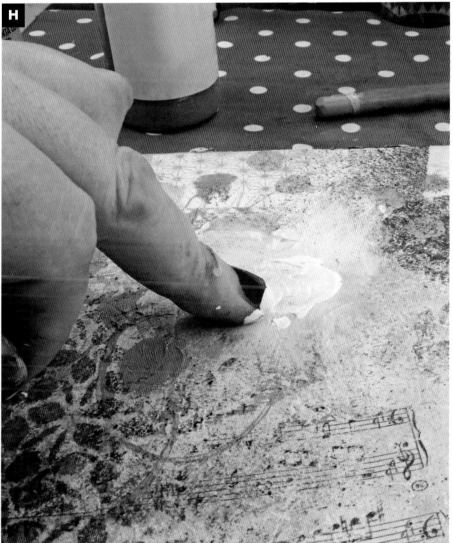

5. I felt moved at this point to play with some acrylics and use my fingers to make marks (**E**). (Be sure to check the toxicity levels of the paint if you choose to paint with your hands and protect yourself accordingly.)

6. I also added some marks with some acrylic ink and used an old tissue roll as a stamp (**F**).

7. Then I reached for my stencils and ink sprays (**G**).

8. I felt the painting needed more contrast, so I added light patches of white gesso with my fingers (**H**).

9. I then felt like adding some rubber stamping because I wanted to create more texture (**I**).

10. At that point, I wanted to start adding imagery intuitively. Floral, leaf, and heart shapes came to me (**J**). You can use a water-soluble colored pencil (such as Stabilo All) or one that isn't water-soluble (such as Prismacolor). Just be aware of what you're using because Stabilo All pencils react to water intensely.

11. To make your imagery stand out, you could put an aura around the shapes by adding color blocks with watercolor crayons or acrylics (watered down) and blend them out (**K**).

12. With a black pen, I defined and enhanced the lines of the imagery I'd drawn (**L**).

13. If and where I felt called to, I added white marks or patches with white gesso (**M**).

14. With black and white pens, I added little doodles and some words (**N & O**).

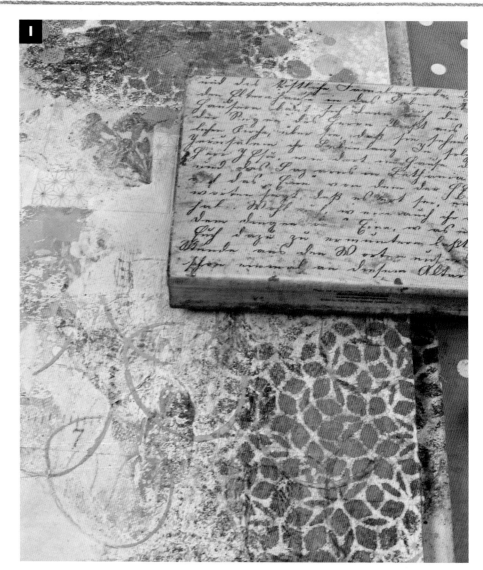

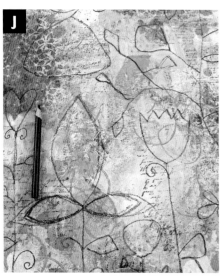

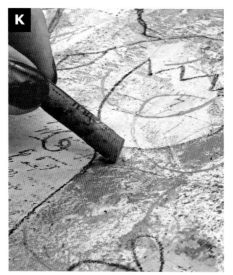

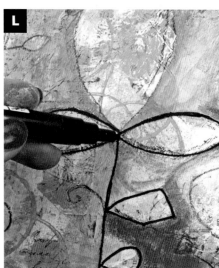

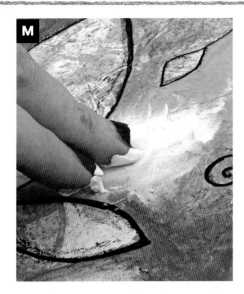

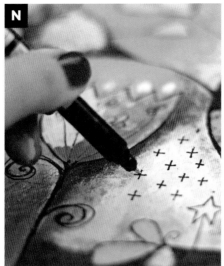

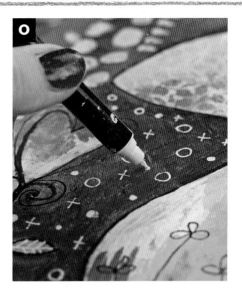

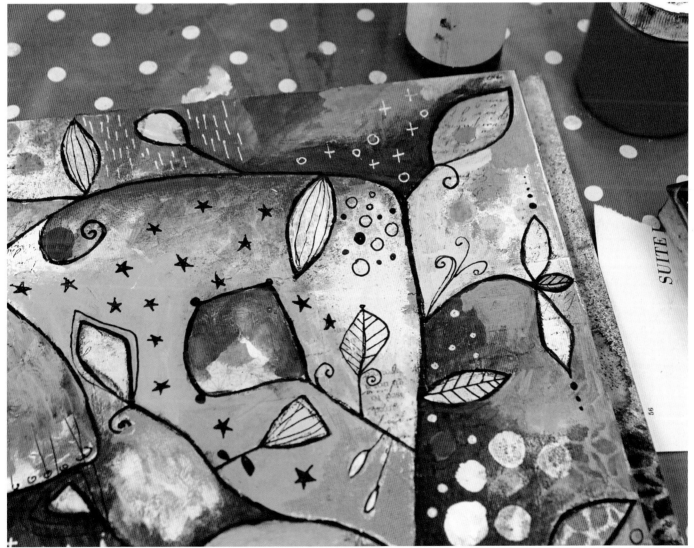

Intuitively Honoring Your Story

Open Up to Spontaneous Creativity

CONTRIBUTING ARTIST MYSTELE KIRKEENG

THE GREATEST PLEASURE for me as a painter is the creative process itself. I especially enjoy creating without any plans in mind (that is, intuitively) because then the entire experience is an adventure that I don't intentionally control in any specific way unless I feel it's needed. This way of creating leaves room for my mind and heart to wander over scripture, to pray, to emote, to think, or to do none of the above. In the end, I'm left with a piece of art that has taken me to creative places I have not been before. Sometimes I even see God, myself, and the world around me more clearly.

Over the years, God has used this intuitive process to help me navigate depression, parenting, marriage, and other personal things. I am still amazed at how the "stuff" we have inside us finds an intelligible outlet through visceral expression. If this "no rules, no plan" type of creativity seems daunting, please rest assured that you have your own gorgeous, creative voice waiting to be unearthed. There is only one you, and that is the beauty of what you bring to your art.

Exploration: Surrendering Control

I believe one of the best ways for you to discover how you speak as an artist is to allow yourself to surrender control of the creative process. When the logical, analytical part of you gets quieter, space is made for you to begin listening to your life. Choose colors and materials according to how you are led in the moment without second-guessing your choices.

Meet Mystele Kirkeeng

From the moment I encountered Mystele's work, I was enthralled and captivated by the raw sense of expression. When I started working with Mystele, I quickly came to love her enquiring and intuitive process, and I deeply appreciate how her methods and techniques often take the student beyond "the mind" and into "the gut" of creativity. In this project, Mystele encourages you to let go of control and allow your intuitive creative journey to unfold as it must to support healing and personal growth.

As you work, you'll end up creating a visual puzzle that only you can solve in a way that's true to you.

In this process, your personal history, your aesthetics, your joy, your pain, your environment, and so on all collide to inform your gut choices and lead you from one mark to the next in a way that is uniquely yours. In some otherworldly way, the "stuff" inside begins to come through. Allow yourself to follow these creative bread crumbs until you can see a story or image coming together, whether abstract, more realistic, or somewhere in between.

Art Page: Intuitively Honoring Your Story

I worked on this painting with nothing in particular on my mind, but if I'm honest, the American sociopolitical climate was on my heart. So even though I wasn't consciously thinking about it as I worked, I'm certain I was feeling it. Now that the painting is finished, I look at her eyes, and I can see my grief. Yet when I look at the rest of the painting, I see hope and beauty and vibrancy. I'm an empathetic but optimistic person, so the bittersweet atmosphere of the piece is pretty much spot-on! When you allow yourself to work intuitively for a period of time, you'll be amazed at what begins to come out of you. I hope you'll give it a try.

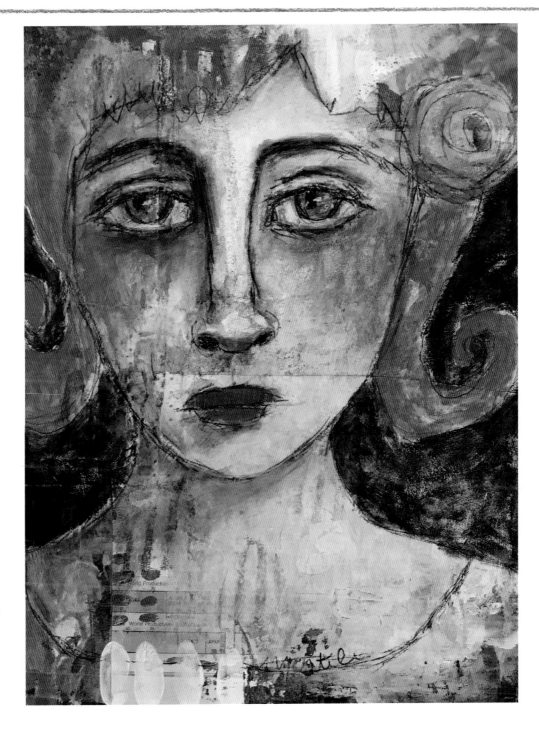

1. Gather enough interesting papers to cover most of your chosen surface. Adhere the papers to the substrate with gel medium or something similar (**A**). I enjoy working on decorative cradled wood panels that I find on clearance at hobby and home decor stores. It's much cheaper than buying raw wood panels from art suppliers. However, you can work on any substrate you like.

2. Begin adding marks as you feel them. Marks can be made with drawing tools, paint, paper, fabric, stencils, stamps, or the like. Continue adding marks until you sense that your painting is full (**B**).

3. Sometimes your background may become chaotic. Unify it with an addition of overall color. I used a brayer to add a bit of titanium white and titan buff to the visual story so I could see it all more clearly (**C**).

4. It's okay to add more color if you sense it's needed. In my case, I needed a bit more color to help things come to life. This is the type of artistic sense you develop as you practice and begin to understand your creative voice (**D**).

5. Begin to abstract the image(s) from the background. This is akin to cloud gazing. I simply do loose sketches around what I see (usually faces or a figure) until I have a basic skeleton to build upon (**E & F**).

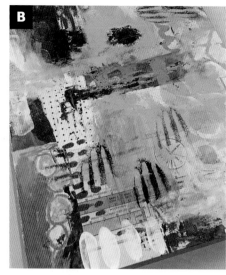

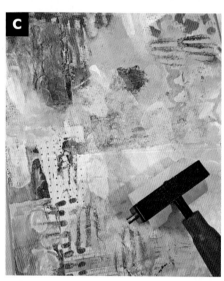

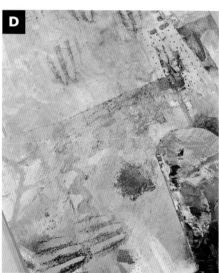

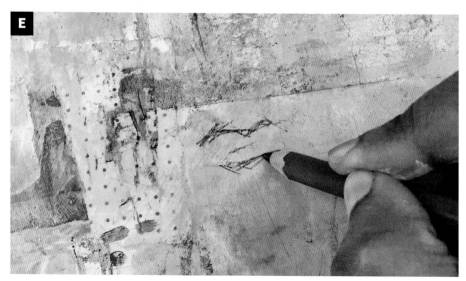

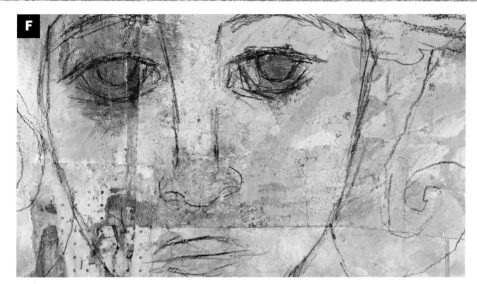

6. Once the framework for the image is clear, add color wherever you feel led to do so. The negative space (the area around the face) called to me, so I started by laying in color there (**G**).

7. Continue adding color and definition. I quite liked the ground created by the papers and mark making, and I wanted to capitalize on that, so I slowly built up light layers of color that would allow the background to peek through. Sometimes I'm not as interested in the background, so I'll add more opaque layers of color to define the image (**H**).

8. I'm not certain any painting is ever completely done, but you'll reach a point where it feels more complete than incomplete. That's also an intuitive decision you'll become more comfortable making the more you afford yourself the opportunity to freely express yourself (**I**).

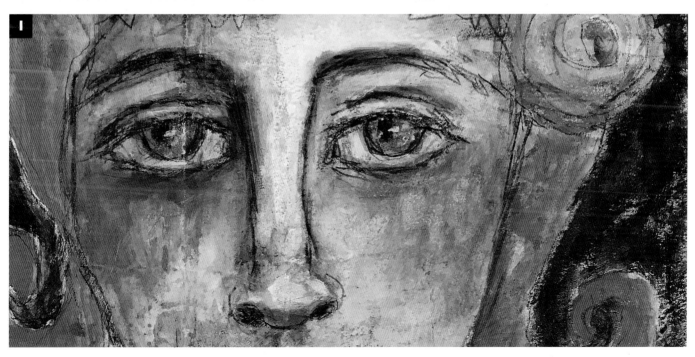

Be Your Own Angel

A Mixed-Media Self-Portrait to Inspire Self-Love

CONTRIBUTING ARTIST IVY NEWPORT

THIS SPECIAL PROJECT is all about self-love and self-protection. We know there's that part of ourselves that's all-knowing and all-loving. That's the part I want us to focus on in this piece.

Beginning with a written exercise, we'll focus on defining what we need protection from, how we can protect ourselves, and how self-care and love can truly enrich our day-to-day existence. We'll examine what self-care looks like to us and how we can practice it. Also, through exploring symbolism, we'll define symbols (wings, birds, angels, crystals, faith-based symbols, animals, etc.) that help remind us to love ourselves more often.

jot down the thoughts that come to you. No need to worry about how it looks. We'll be covering over all this.

- **In the second bubble, write "Self-care."** List the things that make you feel loved and cared for. They could include taking a bath, getting a massage, reading in bed, or the like. Be specific. Write down everything you can think of.
- **In the third bubble, write "Symbols of Protection."** I want you to think about symbols that mean protection or love to you. This could be the cross, hearts, birds, or symbols from your ethnicity or religion. There's no wrong answer here!

Exploration: Recording Words & Symbols of Love & Care

Make three circles on your watercolor paper. You'll be writing about something different in each bubble.

- **In the first bubble, write "What do I need to protect myself from?"** Explore this question and

Art Page: Be Your Own Angel

Once you've sketched and written answers to the key questions about self-protection, self-care, and meaningful symbols on your painting surface, you'll incorporate them into your own unique image that expresses self-love.

Meet Ivy Newport

I resonate strongly with Ivy's view that expressing our creative selves fosters joy and healing. I love Ivy's intention to nurture fellow artists on their creative journey so they may blossom and grow. Ivy's art is often imbued with deep emotion and storytelling. In this project, Ivy guides us through an exercise that looks at how to engage a creative self-love, self-protection, and self-care practice that can enrich your daily life.

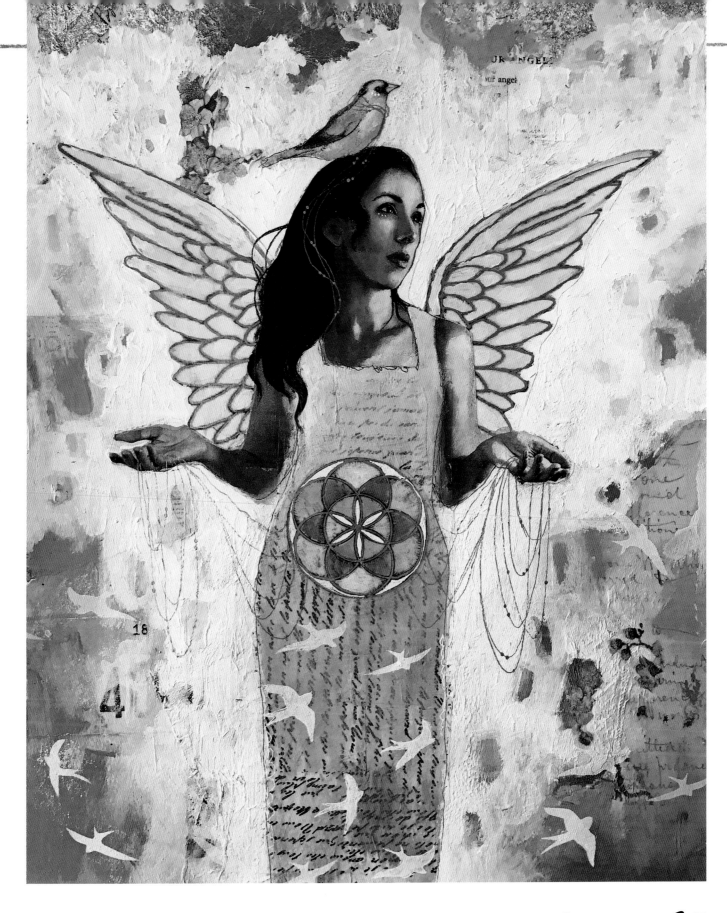

Collage the Background

1. Use collage papers that appeal to you. This provides an interesting place full of texture and color to start. You can incorporate symbols here, too! I used the number 4 because it's an angelic number (**A**). I used Golden Soft Gel Medium as my glue.

2. I decided to add gold leaf to the top edge of the background. I just love the shimmer of gold. It makes me think of divine light and prosperity. I added the same gel medium and then applied the gold leaf. I brushed away the excess with a rough bristled brush (**B**).

3. Add a photocopy of yourself into the piece. I used a laser-printed black-and-white photocopy of myself. I found the wings online and printed those out too. These elements provide the groundwork for the painting. Alternatively, you could draw yourself freehand. If you don't want to work with an image of yourself, you could choose an image of someone else who represents you, an animal, or another image that you know represents you.

Add Color

1. Choose a color palette. Use one that you find soothing and appealing. I chose soft pinks, peaches, and greens. You can see that these colors are also reflected in my collage pieces (**C**).

2. Paint your colors on in patches around your figure. I often do this part with my fingers! Be careful not to mix warm and cool colors together, which results in a muddy color. Let dry (**D**).

Develop the Figure

1. I finished off my figure by collaging on more paper to form a dress (**E**). I love the script-like writing on it because words mean a lot to me and I often express myself in poetry or stories.

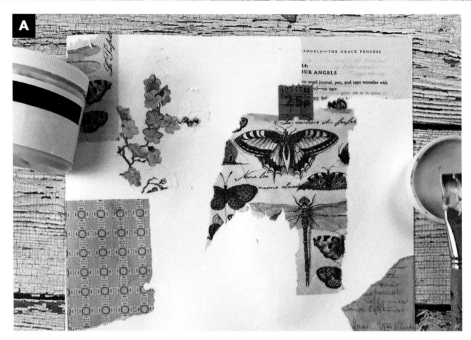

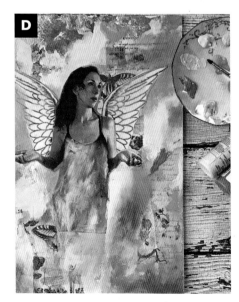

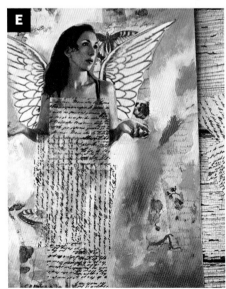

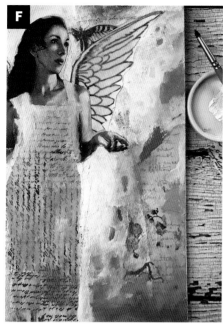

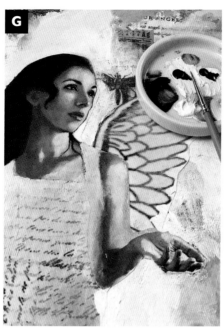

2. Using white paint, start to paint out some of the collage around your figure. I left little windows of color showing through (**F**).

3. Using white, black, and a little Payne's gray paint, I carefully painted some of my skin and features, including the hair, to give the photocopy a more painted look. Follow the lights and darks that are already in your photocopy as a guide. I used no water and very little paint to achieve this (**G**).

4. Add texture. I used Golden Heavy Gel (Matte) mixed into white paint. I again applied it around my figure. This also helps minimize the cut-out look (**H**).

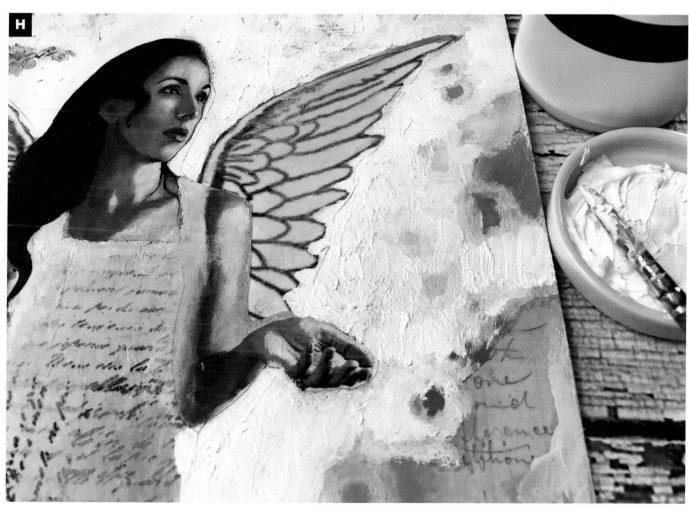

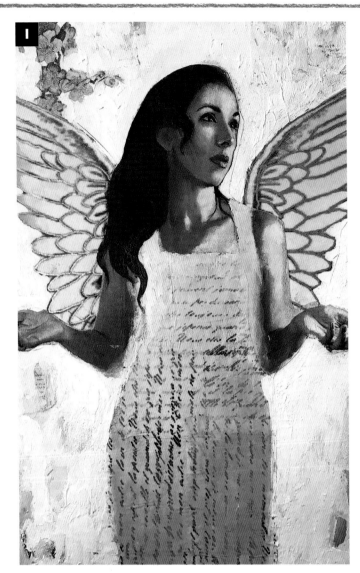

I

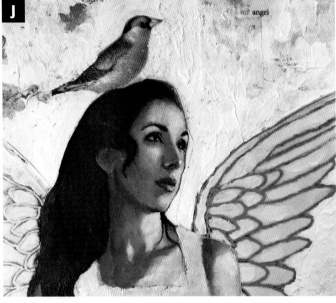

J

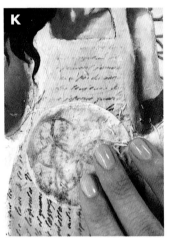

K

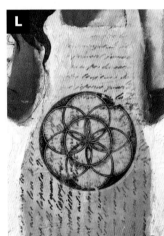

L

Add Details & Finishing Touches

1. Using a gold gel pen, I outlined the wings. This adds a beautiful touch of shimmer and connects it to the gold leaf at the top of the page (**I**).

2. Add a little friend. For me, birds are beautiful symbols that remind me of joy, freedom, and love. I often feel like I have a sweet bird watching over me, so I added him into my composition (**J**).

3. Add more symbols. I decided to add a symbol I love very much—the Seed of Life or the Flower of Life. This, to me, is a very powerful feminine symbol. I did an image transfer to apply this: I coated a laser photocopy in a thin layer of gel medium, placed it facedown, and burnished it. Then I let dry. Then with moistened fingertips, I gently rubbed away the paper to reveal the transfer (**K & L**).

4. Here I used a stencil of birds at the bottom of the piece and into my gown, again repeating the bird symbol. I used a makeup sponge and white paint (**M**).

5. To further incorporate the symbol I transferred, I added paint from my color palette and white and gold gel pen details. I also added some paint to the bird's body to connect it to my colors (**N**).

6. I added in further details with my gold and black gel pens. You see this in the golden strands in my hands and around my bird's neck (**O**).

7. Add a glow. I used my artists' painting pastels and my fingertips to gently run a slight golden glow around the Seed of Life symbol and the bird's little head (**P**). Light is symbolic of hope, love, and of course, angels!

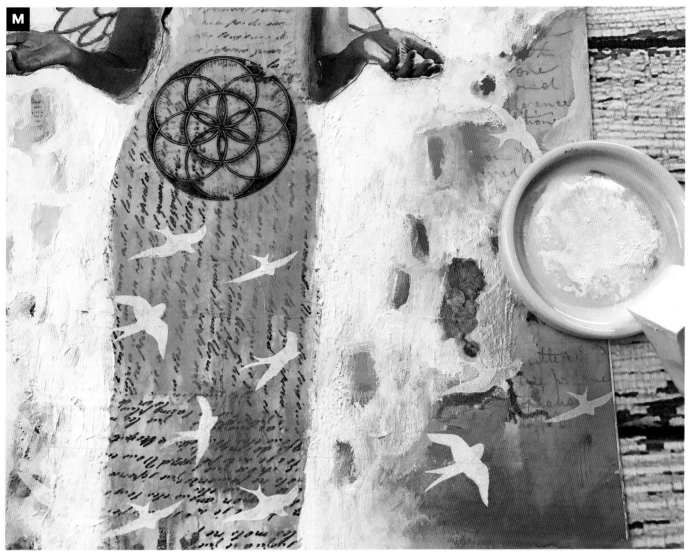

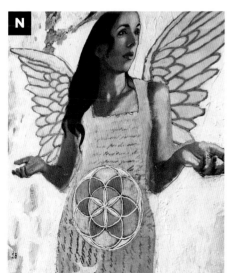

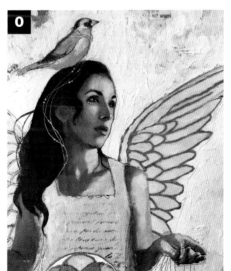

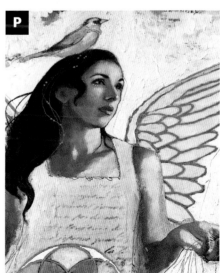

3

Honoring & Healing

THE PROJECTS IN THIS THIRD CHAPTER take a more intentional look at our life experiences and the stories we attach to them. We will look at some of our childhood stories, inner critic thoughts, self-judgments, and limiting beliefs, all of which may contain unresolved pain. We then work on generating healing through deeper acknowledgment and transformation of these stories.

The first project focuses on clarifying and honoring experiences and stories from your past. We move through to engaging a process of healing in which self-critical and limiting beliefs can be transformed. We end this chapter with the promotion of empathy and self-forgiveness and an overall reframing of our stories that we can take forward.

A big part of the healing process is to honor our stories and experiences in life. And from this place of honoring, we can generate empathy and understanding. By converting negative self-talk into empathy, we can both transform our past and equip ourselves for a more loving, connected future.

A Little House of Love & Healing

Your Story Matters

FOR MANY OF US, much of our pain, unwanted behaviors, sadness, and depression stems from events and trauma that happened to us in childhood. Unprocessed and unresolved pain from that time can linger and manifest later in life as physical or mental ailments. As part of my own healing journey, I try to spend a lot of time on giving love to and healing the inner child.

The project that follows is intended as supplemental to any therapy you may already be undergoing. Please do not consider it a replacement for therapy. For the purposes of protection and safety, work with an issue that has a minor emotional charge. Once you feel more familiar with the exercise and if you found it beneficial, you could work on more intense issues, but only do so within the boundaries of your own limitations. Be sure to have a support network around you in the form of family, friends and/or a medical professional such as a therapist.

For this project, we're creating a "safe house" or a "little love house" for our inner child. The idea here is to let your inner child come out and play while simultaneously creating a symbolic house for her that feels safe and loving. When creating your little love house, use colors, items, materials, and images that you would have liked as a child. Use symbolism that expresses safety and love for the inner child. Look at what was lacking for you as a child and try to create the opposite of that on your page.

You can work generally, or you can work on a specific issue.

Be the loving, compassionate parent you may not have had to your inner child.

Exploration: Writing a Letter from "Parent" to "Child"

As part of the first steps of creating this work, we will write a letter to ourselves as children from the perspective of a loving, compassionate parent. Think back to when you were a child and choose an issue you struggled with then. For example, I was bullied in junior high school and had a hard time finding support and resolution for it.

Take some time to remember the issue and what you needed at that time. Then take on the role of a compassionate parent and write a letter to your past self, going through the issue. Write the letter with gentle care, love, compassion, and understanding. Consider what you (as a compassionate, sensible adult) would have done to help the child had it been yours. What loving, kind, compassionate things could you have said or done for the child to help during that turmoil? This letter will be written in the little love/safe house we will create for this project.

Art Page: Little House of Love

Begin your art process by gathering your materials, including an image of yourself as a child or an image that will represent you as a child. You may or may

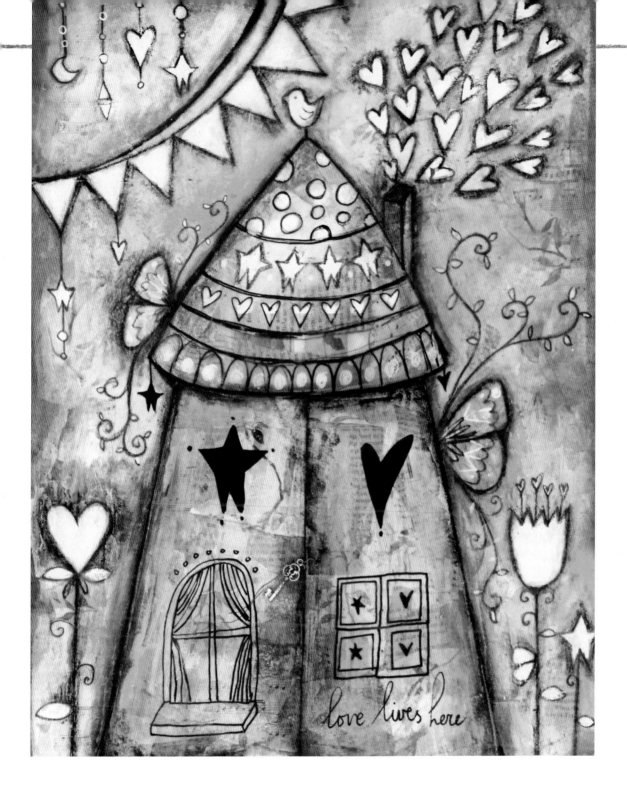

love lives here

not want to include a photo of yourself as an adult. I also printed out pictures of stuffed toys because I used to love them as a child (and still do now!). You can also include collage images such as butterflies, flowers, and dolls—anything that would speak to you as a child.

Draw & Decorate Your House

1. Draw your love house. This is a simple house shape that you can design on your own. Design something sweet and innocent, something that speaks to your inner child (**A**).

2. Write a letter to your inner child from the perspective of a loving, compassionate, gentle, kind adult parent inside the house. What would you have given the child? How would you have protected and helped her? Write with as much love and compassion as you can muster, and let the words sink in (**B**).

3. Now add collage materials over the letter. Use collage pieces that make your inner child happy. I added butterflies, birds, flowers, and stuffed toys as well as general collage pieces and an image of myself as a child. Make the inside of the house as happy, safe, and comfortable as your inner child needs it to be (**C**).

4. Add uplifting colors over the collage. Add any other items that make it happy for your inner child (**D**).

5. With some white gesso, you can unify the layers (**E**).

6. With a black pen, I added doodles to the image of me as a child. Consider what you wanted to be as child or what you needed. Did you pretend to be a princess or a queen? Or did you love climbing trees? What gave you a sense of freedom and joy as a child? Add doodles like that to the image. You can also add uplifting or supportive words (**F**).

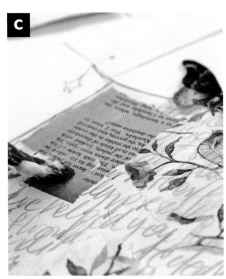

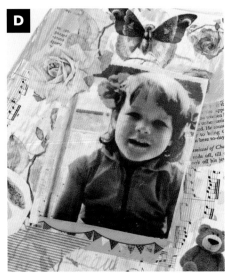

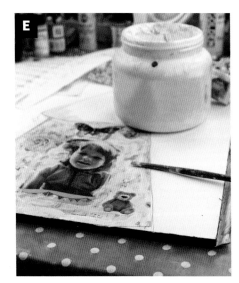

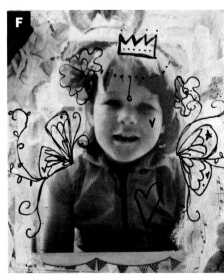

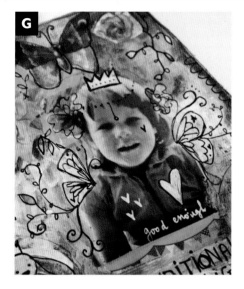

G

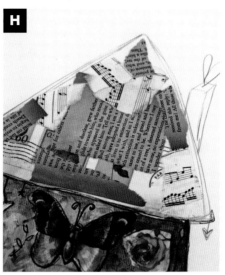

H

7. Continue to add more doodles and to add and intensify colors if desired (**G**).

8. When you're done with the inside of the love house, collage and decorate the roof (**H**).

Trace & Cut the Doors

Using transparent paper, trace over the outside of the house. Cut out the shape, place it on a blank piece of watercolor paper, and trace around it again, allowing for some extra margin on each vertical side of the shape (**I, J, K & L**). These will become the doors to your love house.

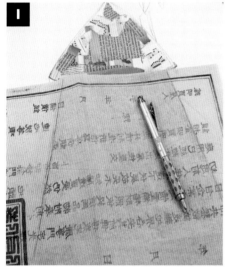

I

J

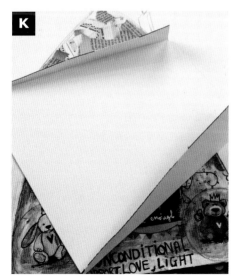

K

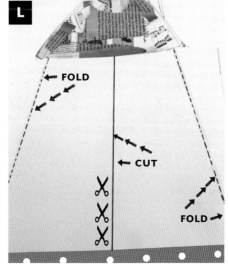

L

FOLD

CUT

FOLD

you are good enough

Develop the Background

1. Continue working on the background by adding collage as you did for the roof (**M**).

2. Add colors to the background using some of those you used inside the house (**N**).

3. To unify the layers, add white gesso with a brayer. To create contrast, I added white patches of gesso to the page with my fingers (**O**).

4. Add doodles that make you happy to the background and roof (**P**). For example, you could have hearts coming out of the chimney, flags in the sky, heart and star flowers, or anything that speaks to you.

5. Add white highlights with a pen (**Q**) and then use a blending stump to add shadows around the doodles (**R**).

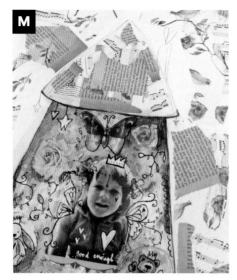

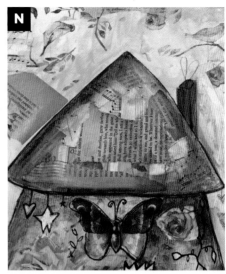

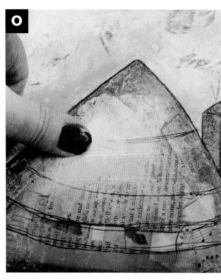

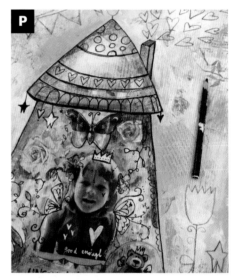

Decorate & Attach Your Doors

1. Decorate your doors as you did the background and roof. To adhere your doors to the page, use a craft knife to cut alongside your wall edges, being sure not to go all the way down. Allow about an inch (2.5 cm) on each side to be uncut (**S**).

2. Cut the door flaps to the same size as the slits you cut and then slide the flaps through the slits (**T**).

3. Tape down the flaps on the back of the piece (**U**).

4. Test the doors to make sure they're secure (**V**).

5. I added words, doodles, and happy symbols to the doors. Remember to add what speaks to your inner child (**W**).

Add the Closure

To keep the doors closed and the inner child safe, I threaded metal wire through two little holes in the doors (**X**). You can use embellishments such as buttons, little silver keys, or other ephemera to hang off the wire symbolizing the door being closed (and the child being safe and loved).

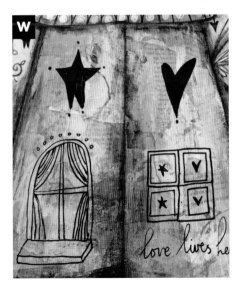

You Have Wings

Transform & Heal the Inner Critic

MANY OF US WERE RAISED with critical parents and authorities around us. We've often lived through all sorts of criticism as children and may have internalized these messages, which pop up all over the place as we go about our lives as adults.

This internalized voice has even been given her own name; the inner critic is a well-known character to many of us, particularly creative types. We often strongly dislike her (or him!) and can easily feel paralyzed and intimidated by her messages.

What is this voice all about? Why is it there? What is it trying to do? How can we embrace or understand it, not let it stifle or paralyze us, and look more deeply at the underlying messages it is trying (clumsily) to convey? How can we make sure that this inner critical voice doesn't stop us from creating and moving forward? Can we find ways to go under the judgment and let go of heavy criticism so that we can allow ourselves to create again? So that we can allow ourselves to make mistakes and messes and ease into being gloriously alive?

There are many ways one can work on the inner critic: We can ignore it and truck on anyway. We can look at positive affirmations. Or we can deconstruct the thinking behind it. Another way of dealing with this inner voice is by listening to it and trying to understand what it's trying to tell us on a deeper level. We'll need to let go of judgment and resistance toward the inner critic and face her head on (i.e., confront your demons). This way we can try to look at the underlying fears and intentions behind the voice and generate compassion and understanding for what is going on at a deeper level.

It's important to understand that the inner critic's words are merely thoughts we've come to believe. They are mere echoes of what our parents, our teachers, or other authoritarian figures told us. We don't have to believe these thoughts or identify too strongly with them.

By looking at what lies under these thoughts and compassionately embracing the feelings and needs under them,

we find more understanding for the inner critic. Through this process of looking more deeply and finding compassion, we're often more able to gently let go of our inner critic's thoughts and try again. Here is the process:

Exploration: Confronting Your Inner Critic

Sit down, take a moment, and write a paragraph of your inner critic's most common critiques in your Life Book Notebook.

Select three of the most painful thoughts and work through them by answering the questions below. Here's an example of how to work through one:

1. **The inner critic says:** I don't like this painting; it's not good enough, and no one will like it.

2. **Ask yourself: What's under this statement?** Which more elaborate inner critic thoughts live there? What feelings live there? What needs live there? What is the deeper intention of the statement or thought? For example: "Why does the painting need to be good enough? Why do you need other people to like the painting?"
 - TRY TO ANSWER *in your most authentic and vulnerable voice, avoid using judgmental language, and dig for deeper feelings and needs. For example: "If people think the painting is not beautiful, they'll think I'm a terrible person and not good enough. If the painting is beautiful, people will think I'm amazing and worthy, and they will like me more. Also, I will like me more. I'll be proud of my achievements. Other people will love and like me more, and they will admire and respect me. If other people love and like me, I'll feel safe and connected in society. I'll be seen, respected, valued, loved, and liked."*

3. **Now notice the needs in your answer.** For example: "I need to be seen, feel safe, have self-worth and self-love, be respected, have connections, matter, and be loved and valued." (For a list of needs, check the Resources on page 139.)

4. **Call upon the part of you that is wise and compassionate,** the one that can validate your feelings and give empathy to the hurt parts of you. If you find it hard to respond with empathy toward yourself, imagine you're responding to someone else you love deeply. As much as possible, avoid using judgmental language and try to simply reflect what you're hearing yourself say.
 - FOR EXAMPLE: *"I'm hearing and understanding that you really want to be safe, valued, and seen. You also really want to matter. You want to experience a healthy, loving relationship with yourself; you want to like and love yourself more. You would also really value being respected by your family and friends. These are beautiful needs to have. I understand."*

Now take a moment and notice—really notice—the beauty of the needs that lie at the core of the inner critic's thinking. The thoughts produced by the inner critic are there because she wants you to avoid getting further hurt or feel those unmet needs lying deeply below inside of your core.
 - "I HATE THIS PAINTING" ACTUALLY MEANS, *"I want to have more self-love; I want to matter, to be seen, and to be safe."*

It puts tears in my eyes just writing this down. By going through this process and listening to the inner critic's words (instead of repressing them) and by looking at what is motivating these thoughts, I can find a softer space within myself for myself and my perceived failures. I create a deeper understanding for the inner critic, and I can give that part of me some empathy and love. When that part of me has been acknowledged and seen, I can let go of some of that inner critic's thinking. I feel braver and more able to start my creative process again.

This process is influenced by Nonviolent Communication, as developed by Marshall Rosenberg (www.cnvc.org) and Robert Gonzales (www.living-compassion.org).

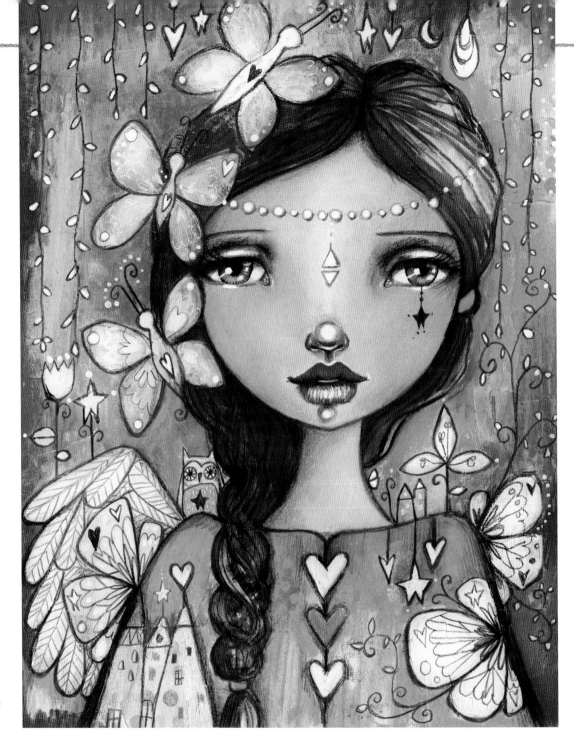

Art Page: You Have Wings

We will create a
front-facing portrait of
a girl with wings, a little
bird or owl, and butterflies around her head symbol-
izing the transformation of the inner critic's thoughts
to freeing, positive, compassionate thoughts. The bird
represents wisdom and compassion for me. Choose
symbolism that's meaningful to you.

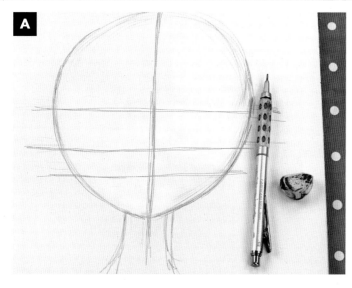

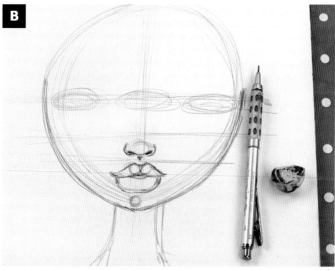

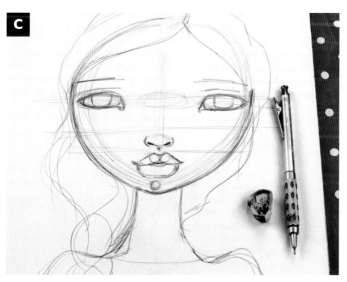

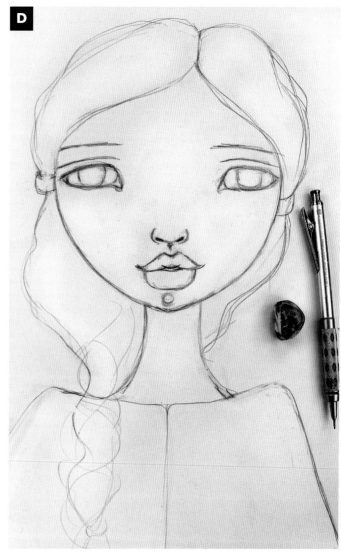

Draw the Girl

1. Use graphite pencil to draw the head and neck. Add guidelines for the midline of the face and the eyes, nose, and mouth (**A**).

2. Place the eyes on either side of the midline, one eye's distance apart. Sketch in the nose, mouth, and chin (**B**).

3. Develop the features and lightly sketch in the hair. Extend the lines of the neck to create the upper body (**C**).

4. Refine the drawing and erase all the guidelines (**D**).

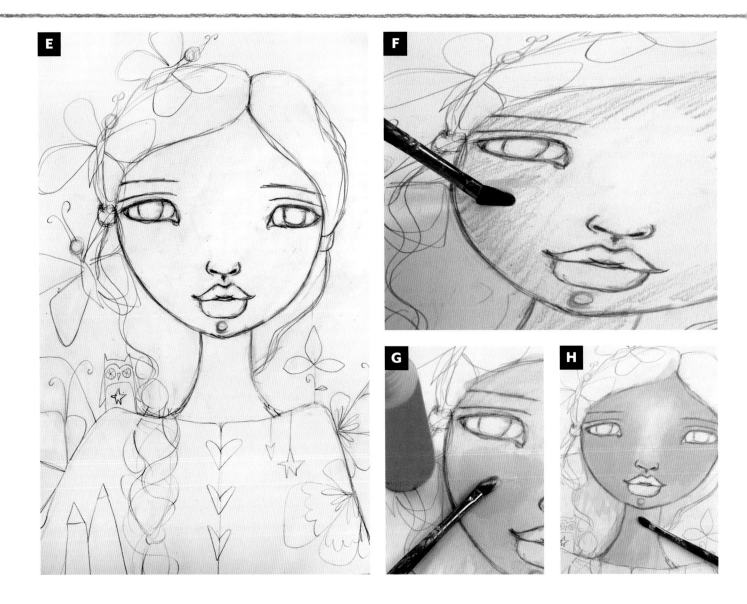

5. Add imagery and symbolism that represents freedom, transformation, wisdom, and compassion, such as butterflies, wings, birds, or anything else you associate with those aspects (**E**).

Add Color to the Face

1. I like to start my light-skinned girls with a water-soluble crayon in a salmon skin tone and then activate it with a wet brush (**F**). To create a darker skinned girl, start with salmon or ochre and build up your darker tones with oranges, reds, and browns.

2. I then often use an acrylic paint in a similar tone as a second layer. Then I build up my darker shading with crayons, colored pencils, and markers (**G & H**).

3. For the eyes and mouth, I like using a combination of Tombow markers, crayons, and Posca markers (**I**).

4. I use white and black pens to add highlights and low lights/dark accents (**J**).

5. I use a mixture of colored pencils and crayons to deepen the shadows around the eyes and nose (**K**).

Build the Background

1. Start with collage and then add water-soluble crayons as a second layer (**L**).

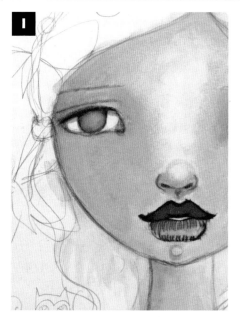

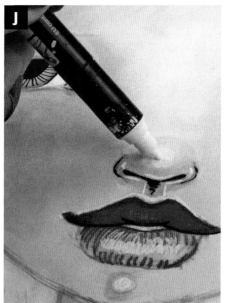

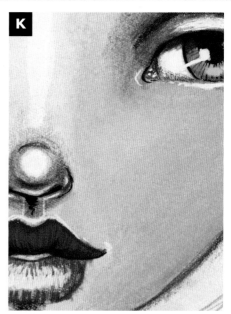

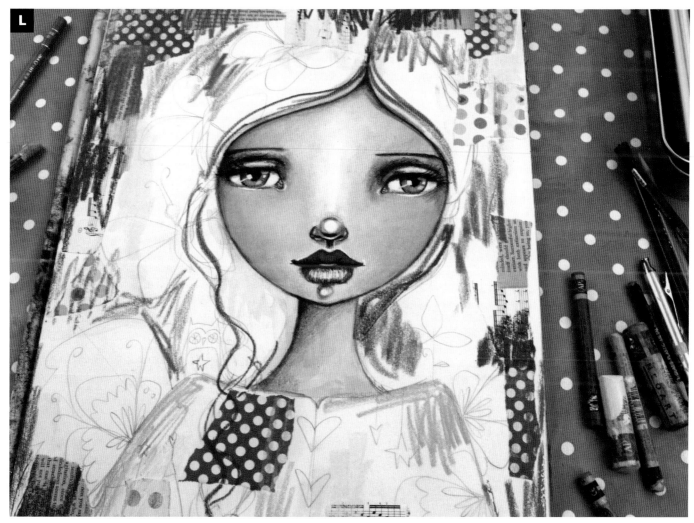

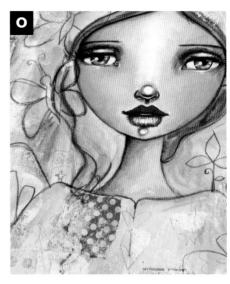

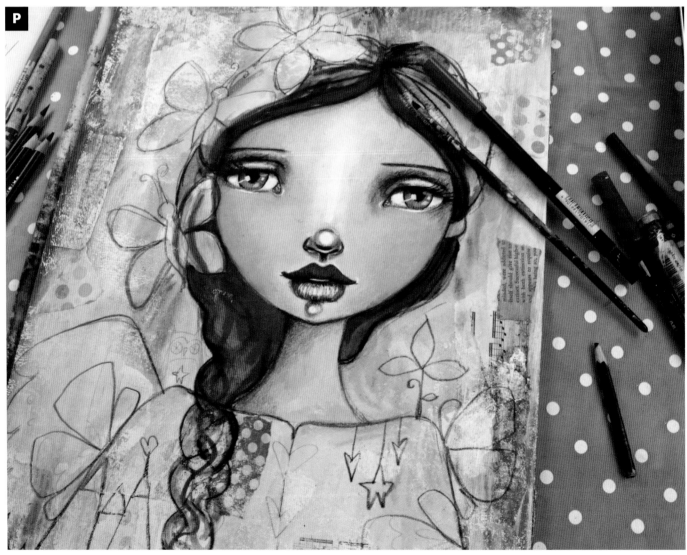

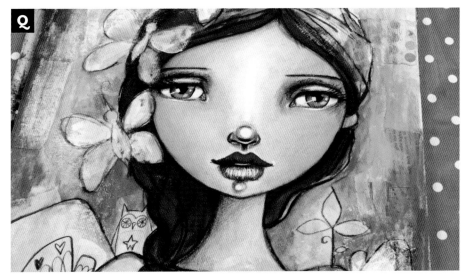

2. Activate the crayons with a damp brush (**M**). Let dry.

3. Add gesso with a brayer to unify the layers (**N**). Let dry.

4. With a water-soluble colored pencil, bring back the doodles and imagery lost while working on the background (**O**).

Add Final Details

1. I added color to the hair with markers (**P**).

2. To create contrast in the background, I added concentrated patches of color (**Q**).

3. I then added detail to the butterflies and other doodles by tidying up the line work and adding in white lines. I also added color to the upper body to make it come off the page more (**R**).

4. As a final step, I tended to all the details by adding highlights and shading and continuing to tidy up the lines (**S & T**).

Fly High

Self-Beliefs, from Limiting to Liberating

FOR THIS PROJECT, we look at beliefs we have about ourselves that limit us.

Many of us take on self-beliefs that inhibit and stifle our happiness, development, or growth. (See opposite for examples.) Sometimes we get stuck—we repeat certain behaviors, even if we don't want to—but we can't figure out why, and we find it difficult to change. Our self-beliefs can feel like deep truths that we don't realize prevent us from moving forward. Often, they're created subconsciously but aren't actually true. We only think they are because they're the beliefs of our parents, teachers, or society or because certain experiences led us to draw conclusions that created them.

These limiting beliefs are only true, however, because we've decided they are. If we accept them—whether consciously or subconsciously—they can stop us from doing what we want. The first step toward changing them is to become aware of them. They only carry weight if we don't examine them.

Exploration: Transform a Limiting Belief into a Liberating Belief

This exercise has eight questions that help us to identify a limiting belief, consider how it may be serving us (often limiting beliefs "help" us some-how), and then how it's untrue and not serving us.

We also call on our deep, inner wisdom to help guide us. We connect with that wisdom by imagining an old wise woman or man who lives inside us. (The archetype for wisdom is a woman, but your inner wise person could be a man.) We ask our wise person, who is considerate and loving, what he or

Sample Exploration

What is my struggle?	What is my limiting self-belief?	How does this belief serve me?	How is this belief untrue?
"I struggle to make art even though I really want to."	*"Making art is frivolous and self-indulgent. I need to do more useful things with my time."*	*"I judge myself when a painting doesn't look good. Thinking that art is frivolous protects me from having to experience the pain and discomfort of self-judgment. Also, people who may share that belief can't tell me I'm wasting my time, which makes me feel safe and gets their approval and acceptance."*	*"Making art makes me feel better about myself, which allows me to be a better person in the world. It's important to do things that bring me joy and make time for things that are less about outcome and more about process and just being."*

she would say to counter the limiting belief, so the responses will be kind and compassionate.

The last three questions ask how and why we might be able to let go of the limiting belief, take steps toward change, and write a liberating belief that is healthy and positive.

To get a feel for this process, start by focusing on one limiting belief. You can repeat or revisit this exercise whenever you want or need to.

As you write your answers to the questions below in your Life Book Notebook, consider the impact of your limiting self-belief or simply shine a light on it—just exposing it can be hugely helpful. See below for an example.

1. **What is my struggle?** Identify an issue or area in your life that you're struggling to resolve or act on.
2. **What is my limiting self-belief?** Identify a limiting belief that relates to that struggle. Ask yourself: Why am I struggling? What's stopping me from moving forward?
3. **How does this belief serve me?** Often these beliefs are helpful in some way. They may have been created consciously or subconsciously to protect us from a painful experience. This step helps us find some compassion for why we have the belief in the first place, which will make it easier to let go of.

4. **How is this belief untrue?** If it's difficult to think of reasons why, imagine the belief is your best friend's—what would you say to him or her about it?
5. **What would my inner wise man or woman say?** Imagine his or her answer to be kind, loving, and compassionate. If you can't connect with an inner wise person, consider what an external wise person would say. That person could be someone you know in real life—for example, a grandmother or good friend, either living or passed on; a character in a book or film; or perhaps a religious or spiritual figure.
6. **How and why can I let go of this belief?** Considering everything you have learned thus far, think about how and why you can let go of this limiting belief.
7. **How can I take a positive step toward change?** Are there any requests you can make of yourself or someone else to help take steps toward changing your belief and its associated actions (or lack thereof)?
8. **Write down your liberating belief.** What is a happier, healthier, more positive belief to have about what you're struggling with?

Examples of Limiting Self-Beliefs

- *I'm not worthy.*
- *I don't deserve to be happy.*
- *My paintings aren't good enough.*
- *I'm not creative; I can't draw/paint.*
- *I shouldn't shine/be seen/be noticed.*
- *Dreams are silly.*
- *Work must be a chore.*
- *I'll never be able to . . .*

What would my inner wise woman/man say?	How and why can I let go of this belief?	How can I take a positive step toward change?	Write down your liberating belief.
"Dear one, your creativity is a gift that keeps giving—to you, to others, and to the world. Keep doing it, even if it's a bit scary. Creativity is a process—it takes time, effort, and practice to improve. Explain to your loved ones that it's important to you that they're okay, but you also need to do things that make you feel okay."	*"Though this belief protects me from uncomfortable feelings, I'm doing myself a disservice by believing it to be true. I want to feel more joy and be enriched by the creative process. I can balance my needs with those of others, and I can talk to others clearly about why art-making is important to me."*	*"I can talk to my loved ones about wanting to dedicate thirty minutes a day to my art practice. I'll explain how important it is to me, and I'll work with them to make sure their needs are met. I'll also work on finding the courage to make art I don't like and looking more deeply into what my inner critic is saying."*	*"Making art helps me feel relaxed, joyful, and better about myself. Spending time on myself is positive and useful. I love making art and will try to make as much time for it as possible!"*

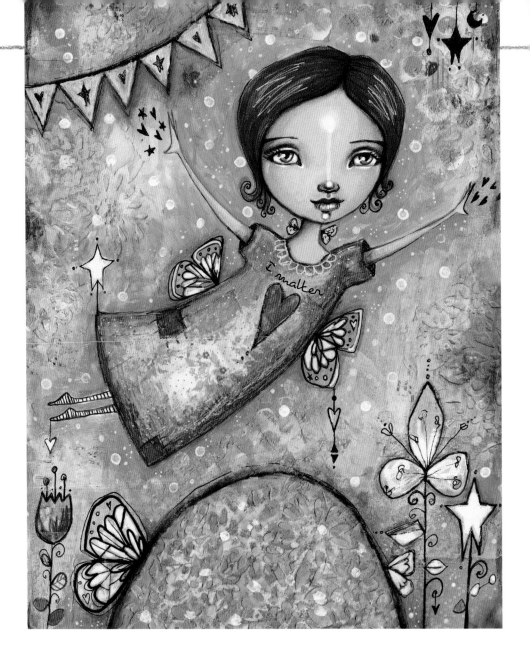

Art Page: Flying Girl

For this art page, we create a girl who flies symbolically over and away from her limiting beliefs, which are written on a hill or mountain. If desired, add words, sentences, or sentiments to her body or dress to represent the liberating belief(s) you've just explored.

Though the design looks complex, it's actually a series of simple shapes. If you're new to drawing figures, make a couple of practice runs on scrap paper before drawing on your watercolor paper. Because the design is whimsical, there's no right or wrong. You can elongate or shorten the body, change the shape of the head or the position of the arms and legs, or whatever floats your whimsical boat!

"what if i fall?
oh, but my darling,
what if you fly?"
—author erin hanson

A

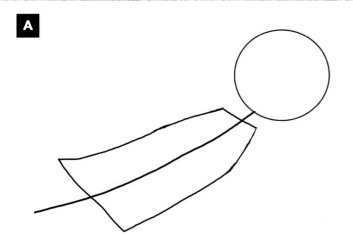

B

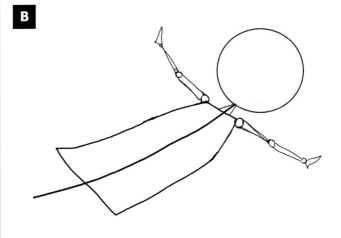

C

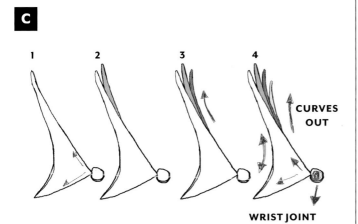

CURVES OUT

WRIST JOINT

D

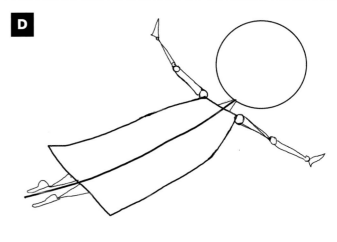

E

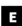 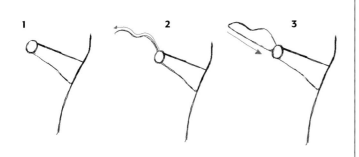

Draw the Body

1. Draw a curved spine line. The curve will help create the illusion of flight. For the body/dress, add a rectangle that narrows toward the neck area. Add a circular shape for the head (**A**).

2. Add the arms. Work in large shapes first, using joint points to determine proportion and shape. Draw whimsical hands by simplifying the shapes while still suggesting fingers (**B** & **C**).

3. Add a leg on each side of the spine line. Start the calf thicker at the top and then gradually make it thinner toward the ankle. The ball of the foot is wider and gradually narrows toward the toes (**D** & **E**).

Draw the Face

1. Start with an oval or circular shape. Divide it in half horizontally with a lightly sketched pencil line. Then halve the bottom half of the circle again twice. Lightly sketch a vertical line through the center of the face (**F**).

2. Lightly sketch the eyes, nose, and mouth on the top horizontal line (**G** & **H**).

3. Refine the shapes of the eyes. Add irises, pupils, and eyebrows and then add hair (**I**).

4. Erase unwanted pencil lines. Strengthen the remaining lines to prepare for shading and/or painting (**J**).

Sketch the Hill

Beneath the girl, lightly sketch a hill and then in it write your limiting beliefs and any feelings or thoughts you have about them (**K**). Later they'll be layered with collage and painted over with flowers to symbolize the transformation of limiting beliefs into liberating beliefs.

Shade the Face

1. Apply a light layer of water-soluble crayon in your chosen skin tone around the edges of the face. Activate the crayon with a wet brush. (Or paint with a wet brush that you've loaded by brushing the crayon directly.) Let dry. If desired, apply a layer of liquid acrylic or craft paint in your chosen skin tone (**L**).

2. Use markers, watercolor pencils, or colored pencils to add color to the eyes and mouth. I often also use these colors on the skin as an initial layer of shading (**M**).

3. Use a white paint marker to add initial highlights to the forehead, bridge of the nose, above the upper lip, on the bottom lip, eyelids, tear ducts, lower nose areas, and chin (**N**).

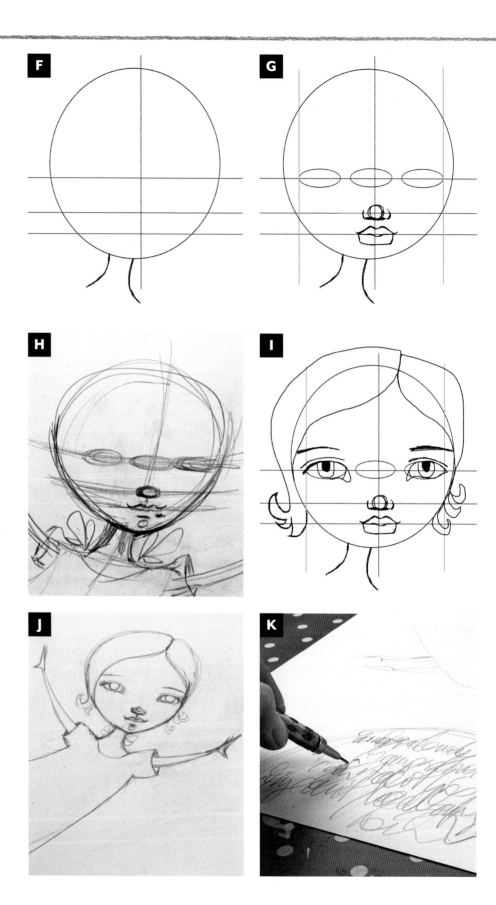

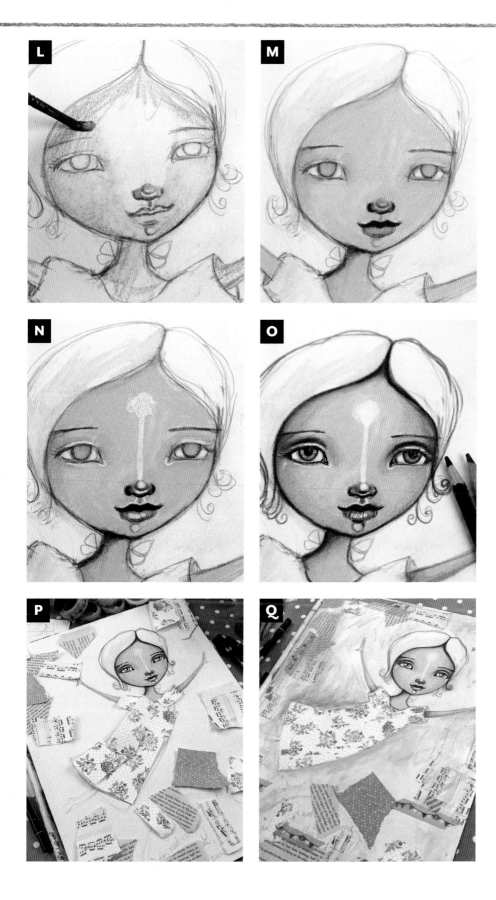

4. Deepen the shading along the edges of the face, around the base of the nose/nostrils, and in and around the eyes with graphite, colored, and watercolor pencils, and water-soluble crayons and markers. Add the darkest accents to the pupils, nostrils, and lips with a black fine-point marker (**O**).

Collage the Background; Develop the Hill

1. Glue the collage elements to the background and in and above the hill. You can also add them to the dress or just paint the dress later. Repeat papers with the same pattern around your page to create unity and overlap them when gluing them down to create visual relationships (**P**). Let dry.

2. Add color with water-soluble crayons and markers and heavy body and fluid acrylics. To decrease drying time, use a heat gun or hair dryer after adding each layer (**Q**).

3. If desired, add color to the dress and hair (**R**).

4. Add a layer of white gesso with a brayer to create a shabby/vintage effect that unifies and softens the background (**S**).

5. Use graphite or colored pencils to strengthen the line that defines the hill. Add a layer of stencil shapes to the hill with spray inks. Let dry. If desired, use a palette knife to apply light molding paste through the stencil and then dry it with a hair dryer or heat gun (**T**).

6. Use a brush and heavy body acrylics to stamp little pink flowers over the molding paste and then add little fingerprints of pink into the surrounding area. To maintain balance and harmony, stencil molding paste over other areas of the painting (**U**).

Add Images & Words

To emphasize healing and personal development, add doodles, symbols, and images that resonate with you and the limiting belief/liberating belief that you're working on. If desired, add a word, affirmation, or liberating belief to your piece that summarizes the belief you arrived at through your personal exploration. If you want to include words or sayings, add them to the dress as a textured layer. I used just one—*I matter*—placing it on the girl's dress, right by her heart (**V**). See opposite for other ideas.

Finishing Touches

To finish this piece, I added dots of white gesso to the background with a cotton swab; highlighted the hair and hanging hearts and stars with a white marker; increased the contrast with color here and there; and made a few other additions that made the painting even more special to me (**W**).

Examples of Liberating Self-Beliefs

- I Have Courage.
- I Am Good Enough.
- I Am Strong.
- I Can Change.
- I Can Do This.
- It Is Possible.
- Shine Your Light.
- There Is Only Now.

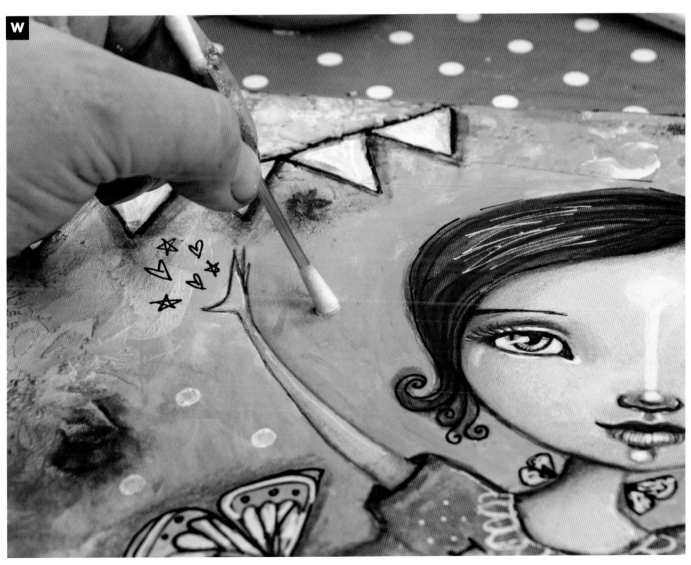

Empathy Affirmation Feather

Self-Forgiveness Helps You Heal

FOR ME, A BIG PART OF HEALING and personal growth is letting go of guilt, shame, and self-judgment. For this project, I'd like to work on an issue you judge yourself for and find difficult to let go. For example, you could use, "I shouted at my children" or "I lied to a close friend." As before, try to choose an issue that does not have too much of an emotional charge for you, just so you can gently learn to understand the process first.

You may wonder why forgiving yourself for acts that have possibly been upsetting or harmful to others is a good idea. Shouldn't we feel guilty, bad, or terrible about ourselves if we've done harm one way or another? I personally don't think so. I know, it's a daring statement, right?

Let me explain. Hanging on to shame and guilt, while understandable, is not helpful, noble, or redeeming. It only serves to darken you, your life, and the people and beings in your life. Blaming and judging the self will stifle and imprison you. It stops you from growing and becoming a better person. You have a much better chance at changing unwanted behavior if you can let go of guilt and shame (forgiving the self) than if you hold on to the harsh inner judgments many of us walk around with.

This isn't intended to justify behaving badly. This is an effective method of helping you heal from deeper pain and preventing you from behaving badly next time you're in a similar situation.

What Are Needs?

When I refer to needs, I am referring to them as defined by Marshall Rosenberg, founder of Nonviolent Communication. They can be seen as our core values, the things we need to feel alive, that which we need to thrive on a deeper level. They're not to be confused with strategies that help us meet our needs but are not needs. For example, a car is not a need, but freedom to move around is a need. The car helps meet the need for freedom. For a needs list, please refer to the Resources on page 139.

This process is influenced by Nonviolent Communication as developed by Marshall Rosenberg (www.cnvc.org) and Robert Gonzales (www.living-compassion.org).

Exploration:
9 Steps to Self-Forgiveness

1. **Try to stop judging yourself.** I know it's not necessarily easy, but try to stop judging what you did. Stop criticizing, blaming, and judging yourself. If you find it hard to stop judging yourself, then first let it all out. Write it all down, scream it into a pillow, or tell a close friend all the judgments that come up for you; then stop. Stop the judging for just some time while you work through these steps.

2. **Try to understand that all actions taken in life are made to meet a deeper underlying need.** This does not justify a behavior that is upsetting or harmful, but it can create an understanding for the chosen action. Where there is understanding and awareness, we have more choices, and changes can more easily be made.
 • SO WHEN YOU SHOUT AT YOUR CHILD, *dig deeply and see what your needs were in that moment. You*

may hear judgmental thoughts, such as perhaps, "My children are so rude to me." But it's likely that underneath that thought is a deep need for respect and understanding. Or you might hear yourself say, "I can't stand the noise; they're so loud!" Underneath that thought might be a deep need for peace and calm.

You want to get to know yourself. You want to connect more deeply with why you did what you did and why you reacted the way you did. With as little judgment as possible, dig deeper for the underlying feelings and needs. What were you feeling? What did you need?

- **Example:** *I feel guilty about having shouted at my children.*
- **My action:** *Shouting/snapping at them.*
- **My judgments:** *I'm a terrible mother and human being. I have no patience, and I am reactive.*
- **What was really happening for me in the moment I shouted?** *I was feeling incredibly frustrated, aggravated, and angry because I needed rest, peace, harmony, connection, and care.*

3. When you've figured out your deeper needs, **sit with the understanding you have for yourself.** Don't rush over this bit. Connect to the needs; feel them within you.
4. Internally or externally **self-empathize.** Empathy is providing a nonjudgmental space for seeing what happened for yourself. Reflect back to yourself, by speaking, writing, or inwardly reciting what was happening for you when you did what you did.

- **Example:** *When the children were screaming, you were feeling incredibly desperate and frustrated because you really needed connection and care. You so badly wanted harmony and respect and peace.*

5. **Express the sadness and pain that comes up.** Express internally or externally any sadness, regret, or pain you feel about your chosen strategy.

- **Example:** *I feel deep sadness and frustration and at times powerlessness around choosing to shout*

and snap. I feel I have no control over my reactivity, which makes me feel hopeless and deeply sad.

6. **Take time to mourn what happened.** Mourning is simply feeling your feelings and acknowledging your sadness and pain about what happened. Avoid falling back into judgment. Just be with what is. Be with yourself and with your feelings.
7. **Actively consider how you can avoid repeating the same behavior next time you're in a similar situation.** Take steps toward that. Seek help and support (therapy, expressive arts, meditation, a sport or exercise routine, relaxation, medication, massage, support from friends or family, etc.).

- **Example:** *I make active steps to help manage my own emotions in high-stress situations. I am going to meditate, see a therapist, and ask for more support from friends and family. I also communicate with my children compassionately, and I engage in a repair process if I do shout.*

8. Now that you understand what happened for you and you've made steps toward choosing different strategies, **forgive yourself.** Let go. Let go of guilt, shame, blame, and judgment. Let go. Let go. Feel the burden lift off you and allow yourself to feel lighter. Your feeling lighter will improve your relationship with yourself, with family, and with friends, and it will improve your quality of life.
9. **Remind yourself how important self-forgiveness is for the betterment of yourself, humanity, the beings around you, and the world.** Understand that self-forgiveness is going to help you change your behavior much more easily and more effectively than beating yourself up and hanging onto guilt and shame. Forgiving yourself puts you in the best space to correct, improve, or change your behavior. It'll make you lighter and stronger and more able to make behavior choices that are less painful to others and yourself in the future. Forgiving yourself after having done the previous steps benefits you and others.

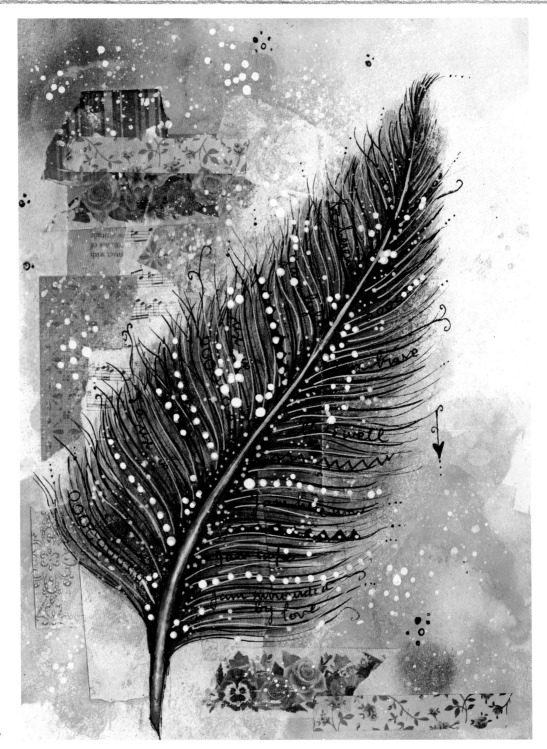

Art Page: Empathy Affirmation Feather

For this project, we will create an empathy affirmation feather containing positive affirmations related to the issue you've just worked through.

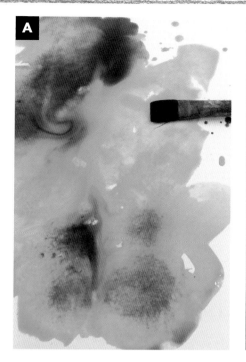

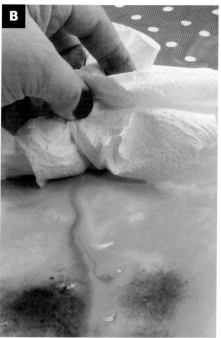

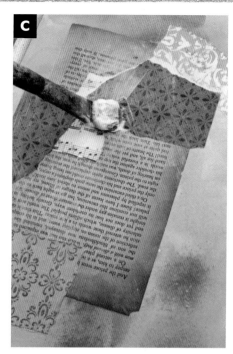

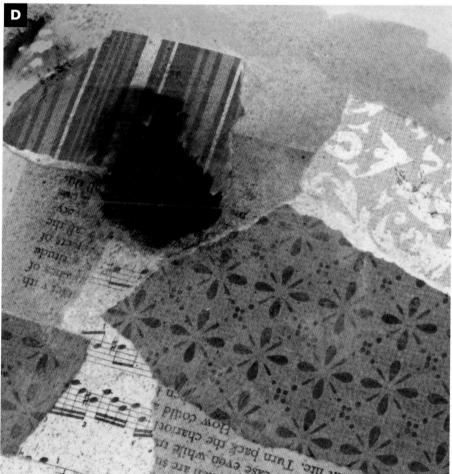

1. Using spray inks in two colors that go well together, create a background wash (**A**).

2. Dab off excess inks (**B**).

3. Add a few pieces of collage to your page, slightly off center compositionally. Apply with gel medium (**C**).

4. Overlap your collage with some of the same inks you used earlier (**D**).

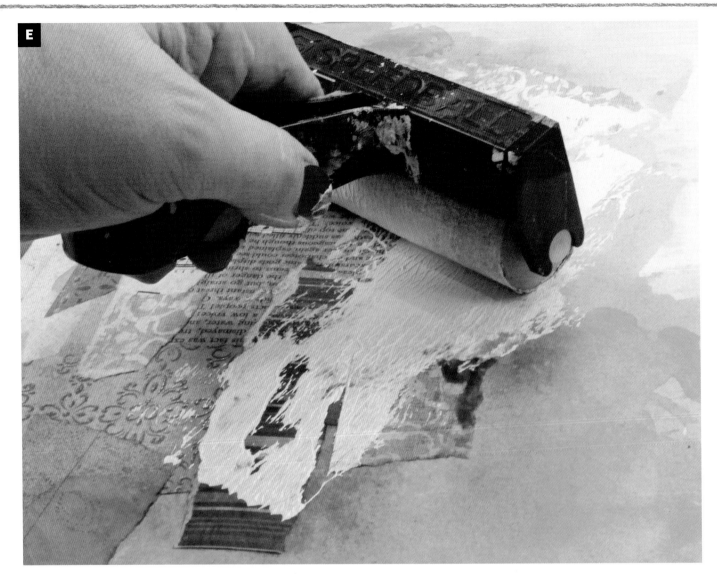

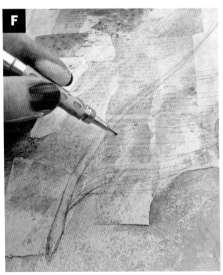

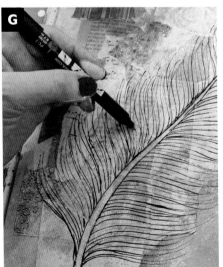

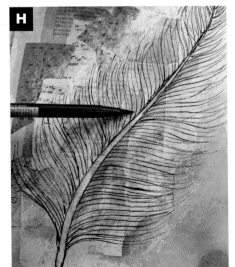

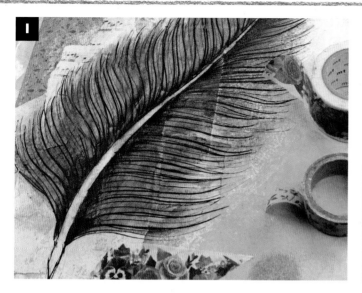

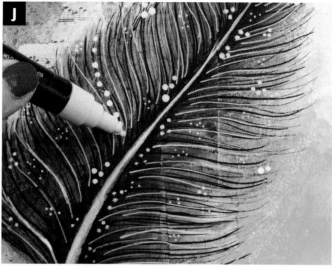

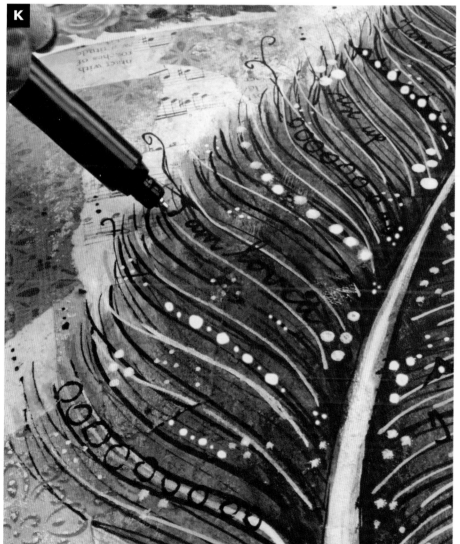

5. Apply a layer of gesso diagonally across your page. Do not cover the entire page. This is where we will draw a feather (**E**).

6. Use a graphite pencil to draw your feather over the dried gesso (**F**).

7. Deepen the lines with a Posca marker (**G**).

8. Using a Tombow marker in a similar color scheme, add color to your feather (**H**).

9. Add washi tape (**I**).

10. Sparkle up your feather with a white Posca marker (**J**).

11. Add affirmations to your feather. Refer to the self-forgiveness exercise and choose positive affirmations that correspond (**K**). For example, if I want to work on shouting at my children less, my positive affirmation might be "I feel calm and full of patience" or "I am kind and gentle." Or, if you need to go deeper, "I am safe," "I am loved," "I am understood," or "I am okay."

Reframing Your Story

Healing through Art Journaling

CONTRIBUTING ARTIST EFFY WILD
PHOTOGRAPHY BY TERI EPP

ONE OF THE THINGS I MOST LOVE TO DO in my art journal is to work with anything that I'm struggling with. I find it very healing and self-loving to be with whatever is present for me in the journal in a way that allows me to glean whatever strength and wisdom from it that I can.

I work with memories a lot in my art journal— stories that I remember from my distant or recent past. Sometimes these are lovely stories, but sometimes, they are charged with difficult emotions, such as heartache, sorrow, grief, despair, or anger.

I don't believe in categorizing my emotions as good or bad. I believe that they are all valid and important. For that reason, I don't like to cover up the difficult things in my journal. I prefer to reframe

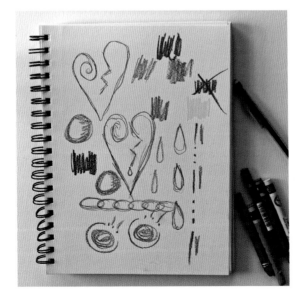

them, so that I build on them in layers without eradicating them altogether. This tutorial is meant to show you how I do that.

Exploration: Drawing Your Emotions

Begin when you have a good hour or so to spend with yourself in your art space. Turn off your phone and social media notifications. Do whatever feels right and good for you as you prepare to be with what is coming up for you.

Gather some simple supplies and a sketchbook. I used a Canson XL Mix Media spiral-bound sketchbook, a pencil, and some Neocolor II crayons.

Ask yourself what story you're holding that you may have a hard time letting go of. It could be anything: the loss of a friend, a lover, or a job; a mistake you made that created a sense of remorse or regret in you; or perhaps something you were told so often in childhood that you came to believe it, even though it was a lie. Whatever comes up for you, let it come. Choose an experience that you feel you can safely work on; perhaps start with something that does not have too much of an emotional charge. Work your way up toward bigger issues when you feel confident with the method.

As you feel whatever you are feeling about this story, begin to doodle shapes that feel like they represent your emotions. I was working with a story about the end of my marriage, so I doodled broken hearts and tear drops, broken lines, and circles with dots and

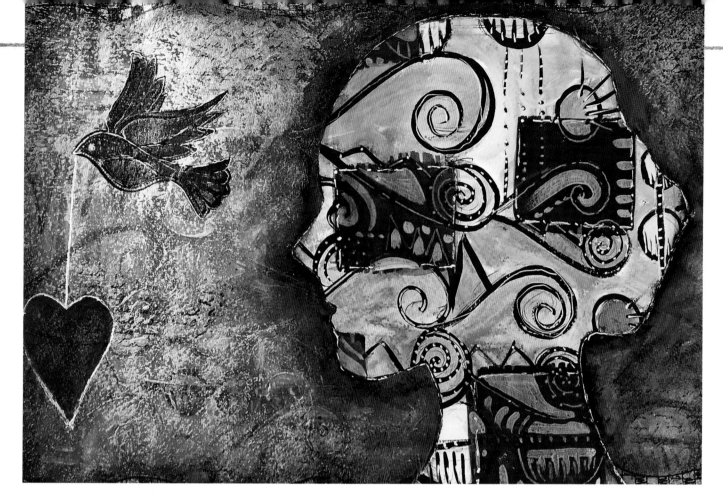

dashes that look like how I felt (see opposite). Trust your impulses. Don't try too hard to come up with anything and especially don't try to create anything fancy. Just make some marks.

Art Page: From Art Journal to Artwork

Once you have marks that represent how you feel about the story you want to work with, put your sketchbook aside and switch to the substrate you intend to create your art on. I'm using a piece of cold pressed 9 x 12 inch (23 x 30.5 cm) watercolor paper (Canson XL 90 lb [185 g/m²]).

Meet Effy Wild

Effy is a treasured friend and colleague who is a master at diving deep, sitting in her emotional fire, facing up to what is needed, and meeting herself (including all her raw parts) on the page. I admire and adore Effy for being bravely authentic, courageously vulnerable, and excellent at guiding others through creative processes and projects that help them work through their own feelings, trauma, and blocks. In this project, she demonstrates how she reframes old stories or memories that carry a difficult emotional charge.

Doodle Your Shapes

Using a waterproof black pen, doodle your chosen shapes all over the page. As you're doodling, imagine that the emotions you feel about your story are leaving your body through your pen. Imagine that the page is taking on the emotions that were stirred up by the story you are choosing to work with (**A**). I'm working with a Pilot PermaBall, but you could use a Pigma Micron, Faber-Castell Pitt artist pen, or any other pen you know to be waterproof. Fill the page and continue to add these doodles until you feel ready to continue to the next step.

Build Color in Layers

1. Add colors that feel like they are relevant to your story. I chose greens because they are the colors of both jealousy and the heart chakra. I also worked with blue because it represents the melancholy that was coming up for me, and pink, because it feels like my tender heart (**B**). I created this first layer using Caran d'Ache Neocolor II crayons, but you could also use Tombow (or any other water-reactive) markers or watercolor paints.

2. Using a brush of an appropriate size relative to your shapes and doodles, activate the crayon (or whatever else you used) with white gesso that you've thinned with a bit of water. You could also use white paint, but I find that I really enjoy working with the toothiness and absorbency of gesso in my first few layers (**C**). Wash your brush between areas, focusing on activating one color at a time. Otherwise, you will end up making mud.

3. Using a round brush and black acrylic paint (I use Golden Fluid Acrylics, but you can use whatever acrylic paint you have), outline your shapes and add little details in black wherever you like. As you are working, keep thinking about your story. You're still allowing your feelings about it to flow through you and into the painting. If you would prefer, you could also do this with black marker (such as Copic or Sharpie), but I love the looseness of paint for this step (**D**).

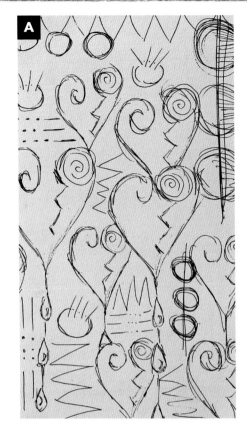

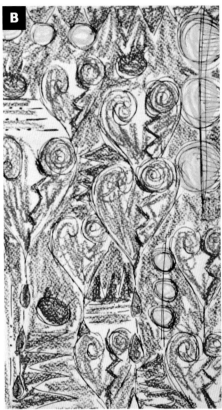

4. Using a waterproof white paint marker (I like Uni-Posca, but you could also use Molotow, Liquitex, a dip pen and white acrylic ink, or whatever else you have), add white embellishments to the black lines in the piece. At this point, I shifted my thinking from the then of the story to the now of the story, by which I mean I started to ask myself what I learned from what happened. I started to explore what strengths I may have acquired as a result of the experience. Let whatever wants to bubble up, bubble up as you add little dots or dashes, swirls, or highlights wherever there are black lines. This has the added benefit of creating a lot of value contrast in the piece (**E**).

5. I added swatches of black paint, which I thinned down with water so that I could still see the initial layers. These swatches were meant to honor the dark times brought on by this experience. It also allowed me to break up areas in the background that felt too busy or too crowded for me. Using the waterproof white paint pen, bring some of the background shapes forward again by outlining them (**F**).

6. With white paint and a paintbrush of an appropriate size for your shapes and doodles, add some light areas into the swatches of black. I followed the general shapes of the doodles and shapes. This was a purely aesthetic choice on my part and didn't have a symbolic meaning, though I suppose it could represent lighting up the darkness (**G**).

7. Using a transparent paint in a color that feels right to you, paint a thin layer to the white areas you created inside the black swatches. I used green gold, which is a color that reminds me of the heart chakra and of growth. At this point, because I'd been doodling, painting, and musing deeply on what I'm bringing forward with me from what I experienced, I had an idea of the focal images that I wanted to use in the next few layers. If you haven't come to that place of knowing what's next yet, keep playing with the shapes and feelings you began with until something—a key word, a symbol, or an image—comes up for you (**H**).

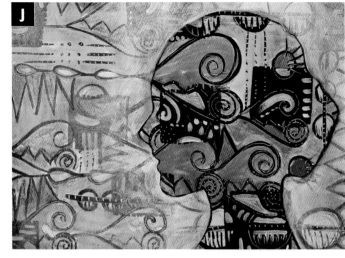

Change Directions;
Add a Defining Image

1. Flip your work. I do this to symbolize a shift in perspective. In this case, I flipped it from portrait orientation to landscape orientation, but I could just as easily have flipped it upside down instead.

2. Choose an image that represents what you are bringing forward (such as a feeling, a strength, or a lesson) from what you experienced. In my case, I wanted to represent my ability to face my past head-on. I chose a silhouette of a female head. You could choose a love heart, a bird, a leaf—anything that looks like the feeling or strength you are bringing forward. I printed the image on card stock and cut it out carefully to use as a mask. If you already have a mask that works for your piece, use it! Otherwise find an image that can be used as a mask, print it out on card stock, and cut it out. Place it wherever you like on the spread and then trace around it with a pencil. I'm using Stabilo All, which is a water-soluble pencil that works on any medium I work with (**I**). You could also use a marker, if you don't mind the outline showing up quite boldly, or a water-soluble crayon such as the Neocolor II crayons we used earlier in the spread.

Add Final Layers & Details

1. Add some water to some white gesso to thin it down and add the gesso all around the image(s) you traced onto your spread. Because I used Stabilo All pencil, adding the gesso activated the pencil and created a delicious inky look to the outline around my focal image. If you find the layer of gesso too thick (you want the background to peek up through this layer), wipe some off with a baby wipe or paper towel. Make sure this layer is completely dry before proceeding (**J**).

2. Add a layer of transparent paint in a color that feels good to you and that relates to the theme of your spread now that you've shifted from then to now. I used Pthalo Turquoise (**K**). It is one of my favorite colors, and it reminds me of the strength of my

heart. Keep this layer very thin so the background peeks up through it. Dry it thoroughly. I also added the same turquoise to the black swatches in the woman's head, but this was purely an aesthetic decision.

3. Using a brayer, add some gold paint. I used Golden Iridescent Gold (Fine) Fluid Acrylic (**L**). Having a metallic bartered on at this point is important to the final product. Use whatever waterproof metallic medium you have for a huge wow factor later.

4. Add a border, some background details if desired, and whatever focal images you like on top of the bartered gold. I used stamps and a waterproof black ink pad for this (**L**).

5. With a Faber-Castell Pitt Big Brush artist pen (I'm using purple), add color around the focal images. Smoosh the ink around with your finger to create a smudged appearance. Notice how the gold seems to shine up through the pen! This will set the piece on fire with glow. If you find that the pen won't smoosh around, stop. Add a

layer of gloss medium to your piece, dry it thoroughly, and then try again. If you don't have the Big Brush pen, you could try Tombows, but be aware that they are very reactive to water, so use a workable fixative (I like Krylon) if you plan on adding any more wet layers. Using a white Uni-ball Signo Gel pen or the Uni-Posca we used initially, add white details to the spread. Outline the focal images. Draw new focal images. I added a love heart carried on a string by the bird's mouth (**M**). And that's it! Tend to your heart's content!

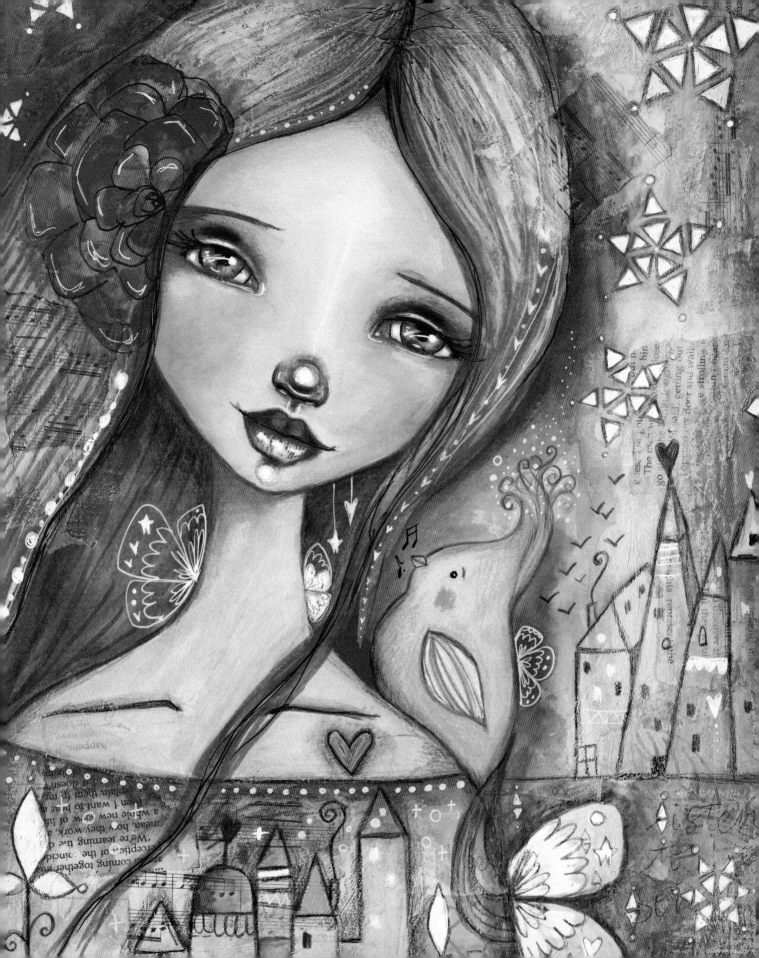

4
Transformation, Strength & Gratitude

AS WE COMPLETE OUR *CREATE YOUR LIFE BOOK* JOURNEY, we start to transform our creative blocks and fears. We experience the powerful use of color for deeper, broader personal change and strengthening our intention-setting. After this, we look at ways to protect our personal and creative journey. We finish with a gathering of gratitude to encourage living a happy life.

The first project tackles creative blocks and blank page fear by connecting to the deeper messages beneath these experiences. Finding compassion for ourselves in the moment helps to move beyond these difficult periods and builds a practice for the future. The next project takes us further on our journey of transformation and change—applying colors and crystals to our own situations to experience support and clarity.

In the third project, we introduce Page Wardens to protect the deep creative journey in which we are now invested. These illustrations are designed to help us continue forward, remain focused, and stay positive during our process. And finally, we end with a project that cultivates acknowledgment and gratitude for all we have in our lives. This lays a foundation for allowing our creative efforts to flourish and bring us joy and happiness.

Metamorphose

Work through Creative Block & Blank Page Fear

ANY ARTIST, NO MATTER how experienced, has to deal with feeling creatively stuck or blocked from time to time. There can be many reasons for feeling stuck.

Exploring Creative Blocks & Possible Solutions

Here are ideas about what might be going on and how to work through your specific issue.

1. **Check back in with your inner critic.** What stories are going on in your mind? Very often, creative block is caused by a rampant inner critic, inner

never compare your beginning to someone else's middle

—jon acuff

perfectionist, or outer critic messages internalized. We may have set ourselves high expectations or tell ourselves that the work "must be great/perfect" and as a result, find ourselves paralyzed and unable to create. If you notice any inner critic chatter, use Project 11 (see page 76) to work through it.

2. **Check whether you are comparing your own work to other work too much.** Comparing your work to other people's works can create a big creative block. Together with this comes the sense that you should be doing what all the other artists are doing (succumbing to trend pressures). Soon there are so many shoulds in there that of course you are going to feel paralyzed and blocked.

 • **IF YOU NOTICE** *that you're comparing your work to other people's work, it's time to come back to your center and put your blinkers on. Take time away from social media and other places where you might see other people's artwork and refocus on your own creative process, bliss, and joy. Remember this great quote from Jon Acuff: "Never compare your beginning to someone else's middle." Honor where you are on your creative journey. Do not get lost in other people's journeys. Every piece of art you make is a valuable, honorable, and courageous stepping stone on your personal creative journey.*

3. **Ask yourself whether you have a fear of the blank page or blank canvas.** Often blank page fear is there because you've got some high expectations of yourself and you don't want to fail. It is also likely that your inner perfectionist is present if the blank page or canvas scares you. A good way of bypassing this fear is falling back into a playful

and tactile approach to art making. First, check your expectations; lower them. Tell yourself, "I'm just playing, and there's no pressure," and then drop back into the body and just start mark making, scribbling, sketching, or play with colors or inks. Do something that is easy and fun to get yourself back into the joy of creating. Do anything you know that you enjoy the process of and let go of having to make a beautiful painting. Playful mark making will help with letting go of fear. See page 108 for two easy and fun techniques you can use to get yourself out of blank page fear.

4. **Eliminate mind noise.** As you've noticed by now, I'm a big advocate for helping creative people get out of their heads and into their hearts and bodies more. Don't get me wrong: I love my mind. It's helped me out on so many occasions. But the mind is limited and can, at times, become repetitive, distracting, overwhelming, and/or a source of major stress and anxiety.

 • IF YOU NOTICE *that you feel stopped by too much mind noise, take a break. Step away from the creative process altogether for a while: meditate; listen to a beautiful song that you love; dance it out; go out for a walk in nature; unwind; slow down; empty yourself of yourself; read a book; quiet your thoughts; come back to yourself, your heart, and your soul; and then when you feel ready, come back to the page and begin again.*

5. **Simply need ideas or inspiration?** Get a prompt or set yourself a challenge. Okay, maybe for you it's not about comparison, blank page fear, or too much noise in your head. Maybe you just feel like you can't think of anything interesting to paint or create. You need inspiration or a prompt or both. Here are some ideas: Start a "prompt jar." Write down a whole lot of words or sentences that you like the sound of (they could even be from poetry or song lyrics), fold them all up, stuff them in a jar, and when in need, pick a prompt! You could also set yourself some challenges such as limiting your supplies, working with only three colors, or focusing on specific topics or themes. Or you could join sites that give you prompts or

challenges; Illustration Friday, for example, sends prompts to your inbox every Friday. Yay!

6. **Find inspiration in your own work.** If you're trying to paint, but you're just sitting there and nothing makes a difference—not starting with a random background, not prompts, and not walks through nature—one thing that I like to do is look through my own work. I search for paintings that I really like and that I remember I really liked making.

 • I LOOK FOR THE ONES *that made my heart sing when I created them, and I simply try and replicate the same painting or the same technique, just to recapture the same feeling and inspiration I had when I created a painting that I really liked and loved. This often lifts me out of creative block and back into action and joy.*

Techniques for Loosening Up

LET IT GO, LET IT FLOW

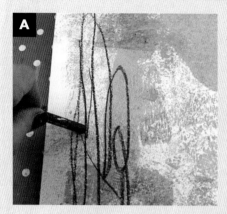

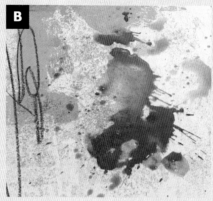

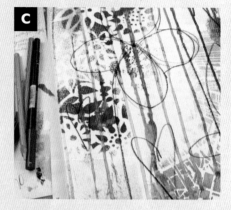

1. *Brayer two colors of fluid acrylics onto your page. Don't worry about what it will look like; consider it playing. Let it dry. Take a crayon, marker, or pencil and start making random marks. Scribble. Express yourself (A).*

2. *Add drips and splatters with acrylic (or other) inks (B). Or start with drips to free yourself up creatively. You can't control where they go; allow them to drip and flow where they want! Use a spray bottle of water to encourage your paints to drip and flow.*

3. *Add stencils randomly. Choose whatever calls you. It doesn't matter; remember you're loosening up and just getting into the creative flow. Then draw random shapes that want to come forth (C).*

MASK, PAINT & STAMP

1. *Use masking tape or washi tape that isn't too sticky. Put it down in a grid (A).*

2. *Brayer paint over the page. Remove the tape once it's dry (B).*

3. *Use random household items and objects to stamp with. I like using the rims of cups, bubble wrap, sponge brushes, the other side of a stamp, and kid toys (C).*

Art Page: Paint Over Collage

I also find this more directed technique useful for getting out of creative block. It's a paint-over-collage technique in which you start with a collage and paint over it to create a completely new painting. I love using this technique when I'm a bit stuck; it's wonderful to have a collage as a base to guide you instead of starting with a fully blank page. It's also a great technique for working on transformation and metamorphosis because the painting changes so much.

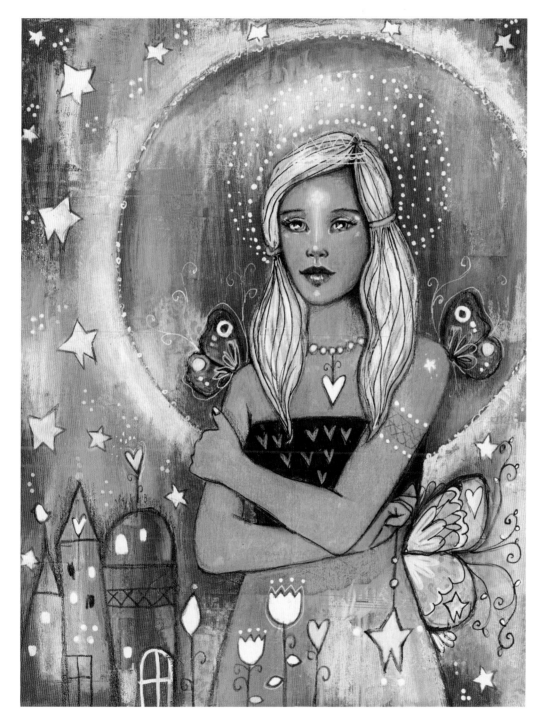

Create Your Collage

1. Gather collage materials from magazines, newspapers, and/or the internet. For this project, we'll include a person of some sort. It's easiest to work on a bigger rather than smaller face. Try not to work on a face that's smaller than 2.5 to 3 inches (6 to 7.5 cm). You'll also need some patterned collage papers such as book pages, musical scores, and scrapbooking pages. Lay out and then glue down your collage (**A**).

2. Apply a layer of clear gesso. This will lock in your collage and give you a new, transparent layer on which you can create your subsequent layers (**B**). Important: Once your collage is glued down and dry, take a photo of it. It's super fun to see it transform. You can also use the photo as a reference if you want to follow the original shading.

Enhance & Embellish

1. Draw over your collage. You can change facial features, add hair, add doodles, or whatever calls you (**C**).

2. Add paint and color over the collage. I painted her face by starting with a layer of salmon-colored crayon (**D**).

3. Add further paint and gesso where you feel called to. I added white gesso to her hair (**E**).

4. With colored pencils, markers, and Posca markers, I added further shading to the face (**F**).

5. I then added color to the background with watercolor crayons, activating them with water (**G**).

6. Add gesso with a brayer to unify the layer (**H**).

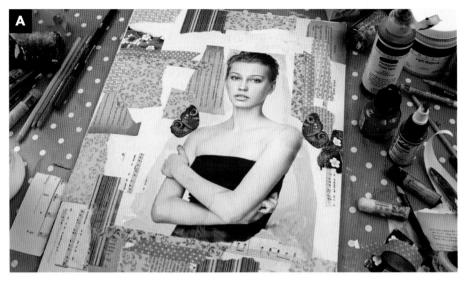

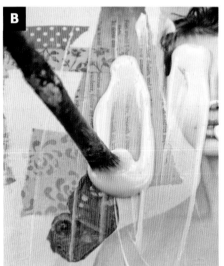

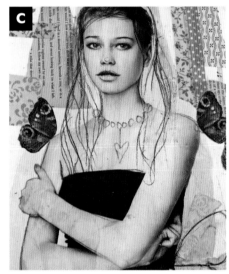

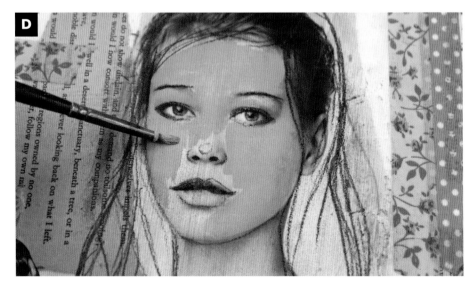

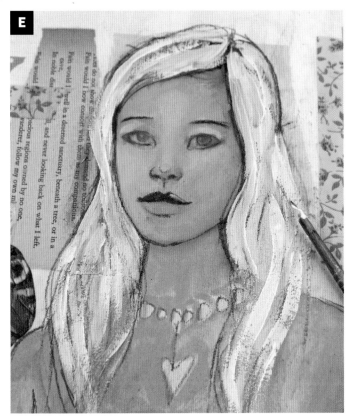

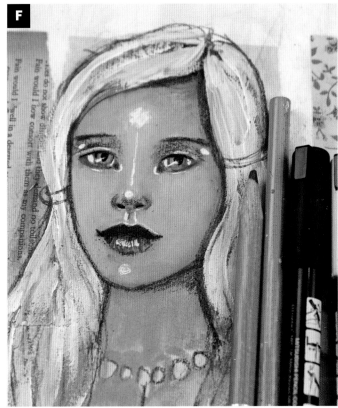

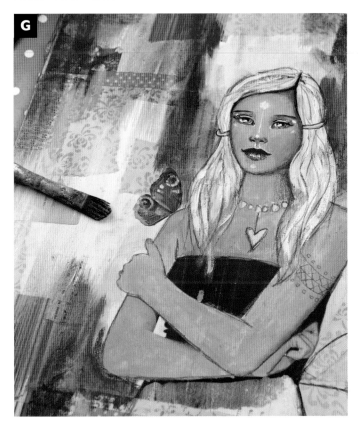

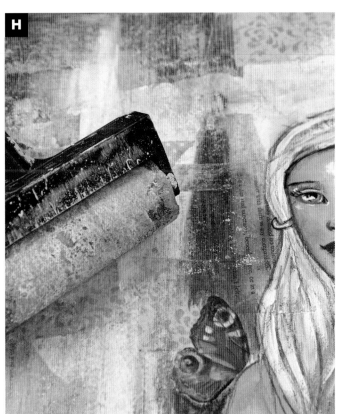

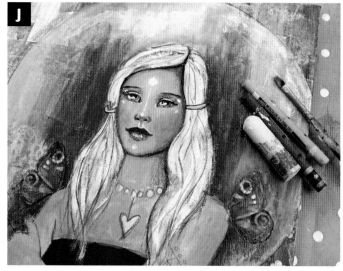

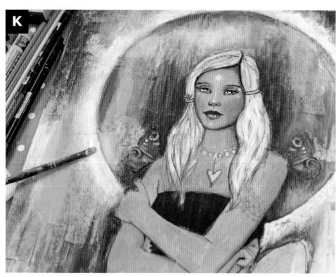

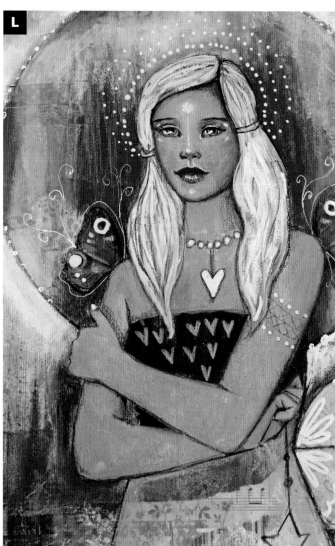

Add an Aura & Finishing Touches

1. I wanted her to have an aura around her, so I traced around a plate (**I**).

2. I added color to the inside and outside of the aura to make it stand out and illuminate the girl's face and upper body (**J & K**).

3. With a white pen, I added little dots and doodles to the painting (**L**).

4. I then added imagery that I love (little houses, floral/natural shapes, and stars). Choose imagery that you like; add it playfully (**M, N &O**).

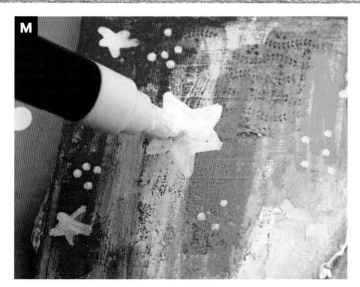

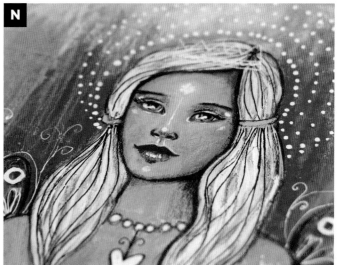

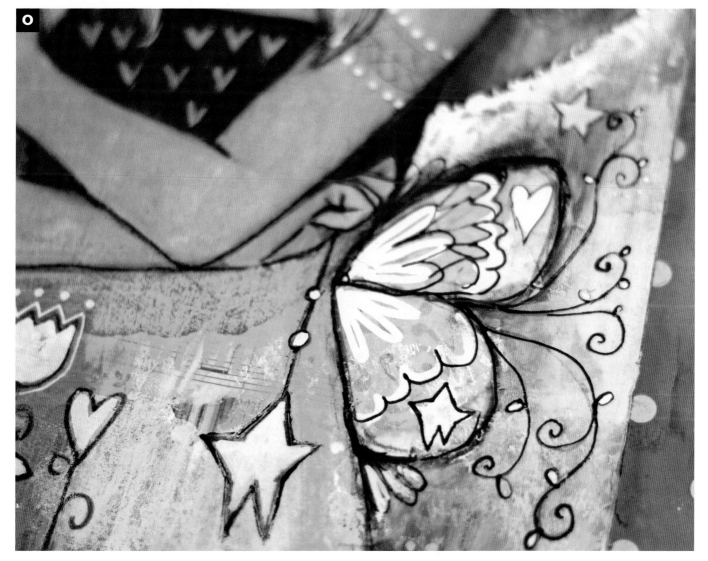

The Beauty & Power of Colors & Crystals

Cultivate Mood with Color

CONTRIBUTING ARTIST ANDREA GOMOLL

Meet Andrea Gomoll

Vibrant colors and playful layering make Andrea's artwork eye-catching, uplifting, and happy-making. Andrea believes that creating art can help people get through rough days while making the "good days better," in her own words. In this project, she demonstrates how you can use colors and crystals to help set intentions that support any transformation you want to undergo.

ASK YOURSELF, "What do I want to bring into my life? What do I need help with? What do I want to change or improve?" Set a goal or intention and pick a corresponding stone or crystal to help you incorporate that intention into your artwork.

When I think of change and transformation, I immediately think of things that can help me with my intention and that can support the process of transformation.

Art in general is a great tool for transformation because it's a constant curve of learning, playing, developing new skills, and improving on what you have learned already. It's a very powerful combination for me to connect art with other things that can be helpful for the process of transformation.

For this project, I have focused on the use of colors in combination with crystals and stones. Both can have a big impact on how we feel.

Exploration: Listening to Color

Colors in general have a big influence on our mood and on our well-being. Red, for example, is a very energizing,

powerful color; blue, on the other hand, is a very serene, calming color. Every color has its very own aspects and influences on humans. Color theory is so much more than just the color wheel! Working with colors that match your intention can be a good place to start with a piece of art that will support your transformation.

Stones and crystals also inspire me a lot and are very powerful. Amethyst, clear quartz, tiger eye, and rose quartz, just to name a few, each hold different energies that can have a positive influence on our well-being and that can help us with our wish for transformation. I love to incorporate crystals into my artwork. Even if you don't believe in their energetic power, they're super pretty to look at. The amazing colors they come in and the endless variety of textures and patterns they have can totally inspire us in our art.

Let those colors and patterns inspire you. Let's listen to our inner voice telling us what we need right now. Need something joyful, inspiring, and energetic? Then red or orange would be a good color to work with, and crystals such as orange calcite and red chalcedony could add beauty and meaning to your artwork. If that's something that sparks your interest, do a little research on the power of colors and crystals.

Colors, Stones & Connections

Each stone or crystal has its own specific meaning and energies that can support you in different areas of your life and personal development. To find your perfect stone(s), you might want to look up specific ones in detail to learn more about the different areas in which they can be used. However, to get you started, here is a short list that can help you pick a color and stone matching your intention.

Colors	Meaning/Supporting	Crystals/Stones
Red	Courage, power, passion, love, increasing energy, willpower	Ruby, red jasper, garnet, red coral, red chalcedony
Pink	Love, beauty, romance, relationships, friendship, acceptance, calming, contentment	Chalcedony, rose quartz, pink opal, rhodochrosite
Orange	Enthusiasm, determination, creativity, self-esteem	Carnelian, orange jasper, orange calcite, sunstone
Yellow	Joy, happiness, mental activity, self-expression, communication, concentration	Citrine, topaz, amber, honey calcite
Green	Growth, harmony, freshness, fertility, luck, intuition, prosperity	Chrysoprase, malachite, jade, amazonite, green aventurine
Blue	Trust, loyalty, wisdom, confidence, self-expression, inner peace, creativity, calm, relaxation	Lapis lazuli, sodalite, turquoise, blue howlite, apatite, larimar
Indigo	Wisdom, insight, realization, understanding, self-reflection, intuition, focus	Azurite, labradorite, covellite
Purple	Power, dignity, independence, mystery, spirituality, imagination, purification	Amethyst, fluorite, sugilite, purpurite
Brown/earth	Grounding, stability, clarity	Tiger eye, petrified wood, aragonite
Gray/black	Power, depth, grounding, protection, patience, self-control, stability	Smoky quartz, hematite, black tourmaline, shungite, onyx
White/clear	Hope, light, clarity, purity, perfection, wisdom, inner peace, amplifying other energies	Clear quartz, opalite, howlite, selenite

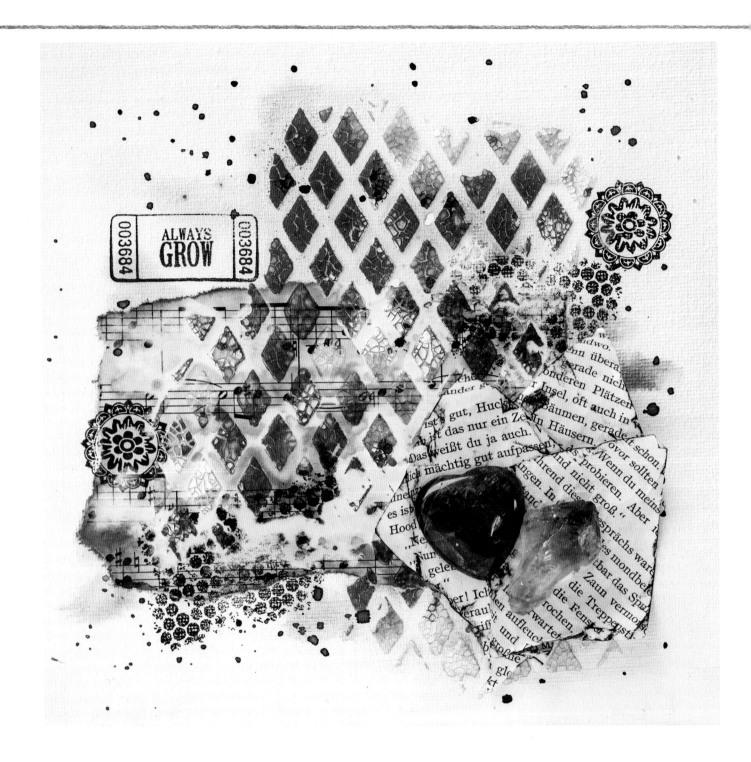

Art Page: The Beauty & Power of Colors & Crystals

I hope you'll enjoy my project, which is inspired by the beauty and power of colors and crystals, and have fun creating these small treasures with me. They're not only fun to make and beautiful to look at in the end, but they're also a reminder of the change we want to attract to our lives.

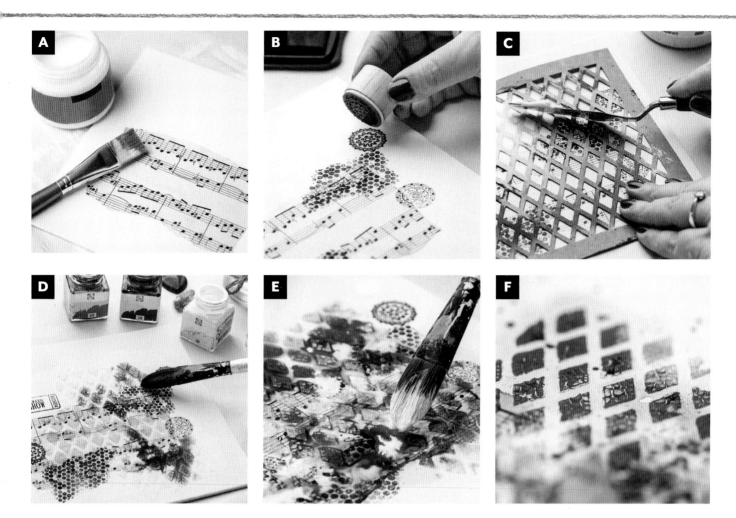

1. Prime your canvas board with gesso. Add two or three even layers of gesso with a flat brush (let it dry between layers) to create a well-prepared surface to work on.

2. Tear a piece of vintage paper (from an old book page, old sheet music, etc.) and use collage glue to adhere it to your canvas board (**A**).

3. Use stamps to add designs and visual texture to your canvas board. Because we will continue to work with wet media, make sure to use a water-proof ink pad for this. Everything goes—just use stamps with patterns and designs you enjoy. You might also want to add stamped words that go with your intention (**B**).

4. Now grab a stencil with a design of your choice, a palette knife, and some crackle medium. A medium that dries clear will give you the best results when adding the watercolors in the next step, so keep that in mind. Put the stencil onto your canvas board, hold it in place, and scrape the gel medium across the stencil using the palette knife. Make sure to leave a nice, thick, smooth layer of the paste for best crackling results. Let it dry for the crackle effect to unfold (**C**).

5. Now pick your color scheme. I decided on a purple color scheme inspired by the purple amethyst stones that I will add to my canvas later. Gather watercolors (liquid watercolors work best, but you can also use tube or pan watercolors with lots of water) matching the color scheme. Also consider some sparkling or pearlescent watercolors for a special effect, as well as white and black for interest and contrast. Load your brush with a watery mixture of the color and lay it onto the canvas. Start light; then add more color step by step and add more water if needed. Enjoy the process and let the colors and the water "do their own thing" on the canvas. That's the beauty of watercolor, and it will result in stunning effects (**D**).

6. For even more fun, you can add in a second color, a special effect color, or white and black (**E**).

7. The crackle medium texture we put down earlier will create a very pretty resist effect now, adding a cool mixed-media touch to the watercolor (**F**).

8. Once everything is dry, load your brush with some more color, hold it close above the surface, and slightly tap it with your finger to add some random paint splatters to the background for a playful touch (**G**).

9. Cut shapes (circles, diamonds, hearts, etc.) from vintage paper. You will need three or four of them for layering, making sure to have some variation in the sizes. Crumple them up and open them again (**H**).

10. Flatten them out, but make sure to keep a little bit of the texture. Slide an ink pad along the edges of the shape for a distressed edge look (**I**).

11. Adhere the paper shapes to your canvas, layering them on top of each other. Only add glue to the center, so the edges are still loose for a dimensional look (**J**).

12. Nest the crystals and stones as a focal point element right on top of the paper shapes (**K**). Again, let your intuition guide you as to where to place the shapes and stones—but I would suggest placing them slightly off-center on the canvas board for more visual interest (**L**).

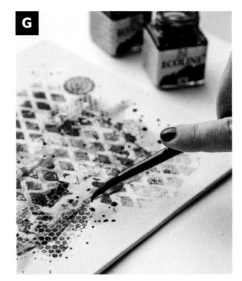

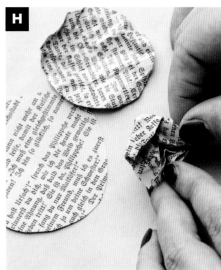

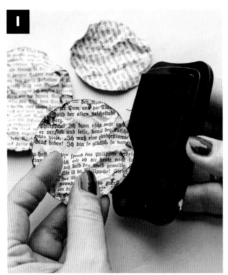

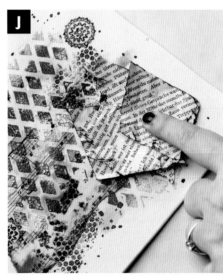

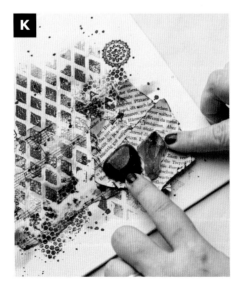

Two more art pages in other gem-inspired colorways

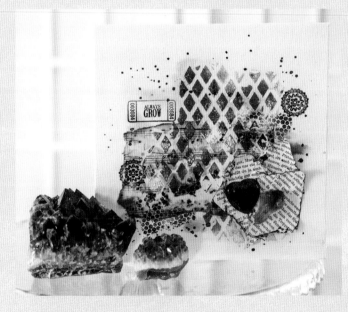
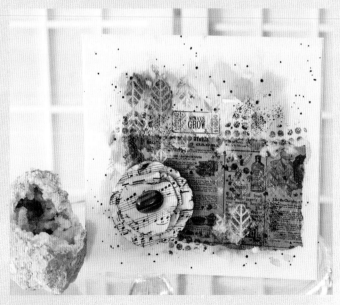

Art pages displayed with the stones or gems that inspired them

Page Wardens

Protect Your Creative Journey

CONTRIBUTING ARTIST ROXANNE COBLE

WHEN I WAS IN ART SCHOOL, I constantly felt beaten down—beaten down by my professors, self-doubt, and an ongoing fear of creative failure. (It's hard to avoid those feelings when you're graded on what you create!) Although these emotions were heightened for me during my fine art studies, let's face it: we all experience this from time to time when making art.

Exploration: Friendly Reminders

One of the greatest things I learned while in the trenches of art school, however, was how to focus positively on my process. I began thinking, "We leave reminders for ourselves all the time in life—sticky notes on the fridge or an alarm on your phone—so why not apply this same idea to creative work?" I did just that. I began to leave notes and reminders for myself around my art studio to stay positive and keep working. Several years later, I still practice this in my studio—and it's from this very thinking that Page Wardens were born.

(Near right) This illustration is inspired by the Three of Cups, which usually pertains to love, socialization, and personal relationships. Known as the most creative card in the tarot, this Warden reminds us to turn to our friends and creative circles when we need to.

(Center) This illustration is inspired by the High Priestess, one of the most powerful cards in tarot. Her meaning is connected to knowledge, wisdom, and subconscious self. She is most closely tied to being a protector or guardian, so think of this Warden as the protector of your creative process and journey!

(Far right) This illustration is inspired by the Wheel of Fortune, which recognizes the ebbs and flows of life. It reminds us that sometimes negative situations or events in life are often out of our control—and not to blame or be too hard on ourselves when they happen. The idea behind this card could also be applied to our creative practice, when we aren't feeling inspired or when what we're working on isn't coming together as expected. This Warden reminds you to not be so hard on yourself!

Art Page: Page Wardens

Page Wardens are the protectors of your creative journey. They're made to be nestled within the pages of your art journal, where they remind you to continue forward, remain focused, and stay positive during your process. For this project, I created three illustrations for you to use. They are inspired by tarot cards, which influence my artwork often.

Each Page Warden illustration, which you may photocopy to include in your art page, is inspired by a card found in a tarot deck. Their meanings are described on the opposite page.

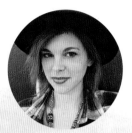

Meet Roxanne Coble

Roxanne's journal pages feature a deep richness of layers and intricacies that seem to contain many stories and worlds within. I have often found myself staring at one of her journal spreads and getting lost in the detail and symbolism. She loves to explore emotions and events in her life on the journal page to support her own healing. In this project, she will guide you through how to make Page Wardens, intended as "protectors of your creative journey," which will help ward off the inner critic and other self-judgmental thinking.

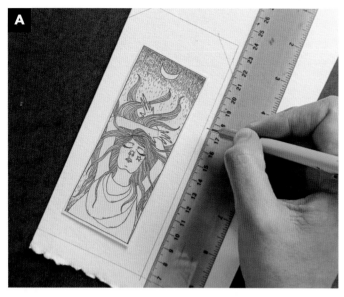

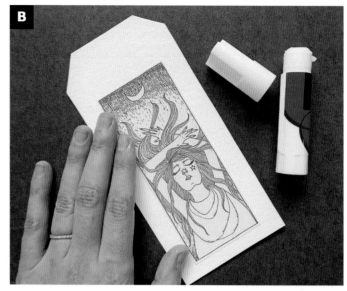

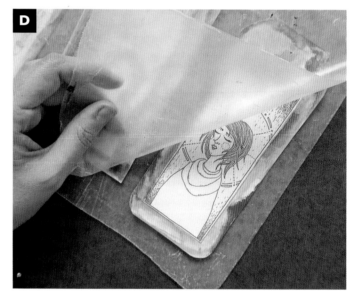

1. Begin by making a photocopy of the illustrations on page 120. (If you want to use your own artwork, create a pen drawing of your own Warden image.) Cut out the Warden you wish to use.

2. Once cut, lay the printed illustration on a piece of watercolor paper to determine the shape of your Page Warden. You can keep it simple with just a rectangle or create a tag-like shape. Leave white space around the printed illustration for watercolor later (**A**). Cut it out.

3. Adhere the illustration or your artwork to your cut-out paper shape using a glue stick (**B**).

4. Using a wet-on-wet watercolor technique, begin by wetting random areas of your watercolor paper using a paintbrush and water. While still wet, apply doses of watercolor paint to the areas where you have applied water. This will cause the pigment to bleed out and create various organic lines, shapes, and bursts of color.

5. Repeat with a second and third color, allowing time to dry in between. Analogous color palettes work best! I also tend to use variations of blues, purples, and pinks to create a more cosmic look (**C**).

6. Allow your painting to dry. Then place it under a heavy book, sandwiched in between sheets of waxed paper, if you need to flatten it out (**D**).

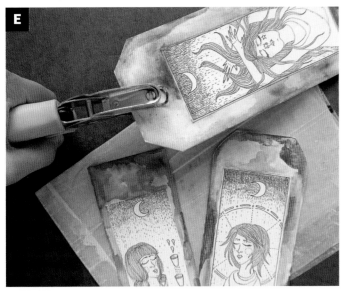

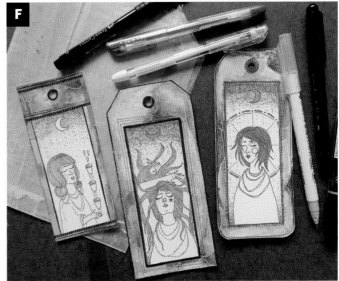

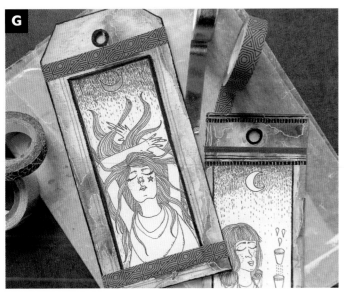

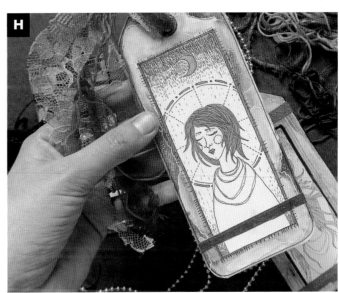

7. After your Warden is flat and dry, punch or cut a small hole at the top for trim (**E**).

8. Add pen details to your Warden by drawing small lines and/or dots or by outlining your watercolor with a gel pen. You can also add washi tape for extra color and pizazz (**F & G**).

9. To finish, tie trim through the hole at the top of your Warden to hang it outside of your art journal (**H**).

Counting Your Blessings

Cultivate Gratitude to Live a Happy Life

A DAILY (OR WEEKLY) PRACTICE of focusing on and recording the things we are grateful for has been shown to have positive benefits in our lives. It can help with:

- alleviating stress
- becoming more mindful
- creating more peace and contentment
- creating more joy
- manifesting more of what we are grateful for

Though we all go through hard times, taking some time in the day or week to look at the things you are grateful for can help shift perspective, help you focus on the moment, and means you are attracting more of what you're grateful for, simply by recounting and feeling joy by reliving the memory.

A note: Focusing on gratitude is not done in a "should" manner. It's not helpful to think, "Even though things are bad for me right now, I should be grateful for all the things I do have." This approach is punishing and doesn't honor the fullness and wholeness of you. If you're feeling resentment or pain over some traumatic or damaging experiences in your life and you're finding it hard or painful to try and be grateful for other things, that's okay and understandable. If this is happening for you, I suggest that instead, before you embark on a daily or weekly gratitude exercise, you spend time honoring and empathizing with the pain you're experiencing first. It's okay to spend time with your pain, feel it, and acknowledge it. This might be a necessary step before you embark upon a gratitude exercise. This is not to say that a gratitude habit could not

help you overcome your resentment and pain, but I would avoid doing the gratitude exercises if you're telling yourself you should be doing them. Work first instead on honoring and feeling your pain.

Exploration: How Do We Cultivate Gratitude?

Cultivating gratitude can be as simple as writing down five things that you're grateful for daily. You can do this in a special gratitude journal or on separate sheets, or you can layer your gratitude list into pieces of art (gratitude art). The point is that you consciously spend 5 to 10 minutes every day focusing on things you are or have been grateful for.

To figure out what makes you grateful (sometimes we're not aware), you can ask yourself questions like:

- What/who made me smile today?
- What/who gave me a sense of peace and contentment?
- What/who inspired me today?
- What/who created a sense of awe in me?

Remember that the things you are grateful for need not be grand things. They can be everyday little things such as ladybirds, the blue sky, avocados (yum!), flowers, autumn leaves, puppies, warm blankets, a smile, your toothbrush, the smell of bath soap, your spouse making dinner, and much more.

some people grumble that roses have thorns.

i am grateful that thorns have roses.

—alphonse karr

Other Ways to Cultivate Gratitude

- **Sit in meditation or prayer for 10 minutes every day** *simply remembering and recounting the things you are grateful for.*
- **Go on a gratitude walk**—*go outside into nature and recount and focus on your gratitude list that day.*
- **Write a thank-you letter to the universe,** *or to a person/thing that you feel thankful for.*
- **Create gratitude art** *(as we'll do in this project!).*
- **Express gratitude, celebration, and appreciation** *if and where you can, as often as you want to and is appropriate. See someone with a beautiful dress?*

Say so! Was someone kind and helpful? Express your appreciation. Did your children make you fill up with love? Let them know about it! This process creates more awareness, joy, and love in the world, and it can also strengthen and enhance relationships.

- **Do random acts of kindness.** *Giving = receiving. There is so much joy in helping others, creating smiles, or even buying coffee for the person behind you in the queue. Random acts of kindness are an instant gratitude and happiness booster, and you're making the world a better place!*
- **Dance it out.** *Choose a song that moves*

you deeply and connects with all living and nonliving things. Dance to it (or simply sit and listen or sing) while absorbing/ feeling the gratitude in you for all that is and all that's ever been.

- **Make gratitude soul cards.** *This is more time consuming. But if you have the time, you can make mini or larger art cards that are specific to the things or people you want to celebrate.*
- **Create a gratitude jar.** *Each time you're grateful for a person, thing, or experience, write it on a piece of paper and put it in the jar. At the end of the year, read through them all as an end-of-year celebration.*

Art Page: Gratitude List

For this project, we will create a list of things we are grateful for (count our blessings) and express gratitude for them on little notes that we'll roll up and put together in a fun and joyful mixed-media page.

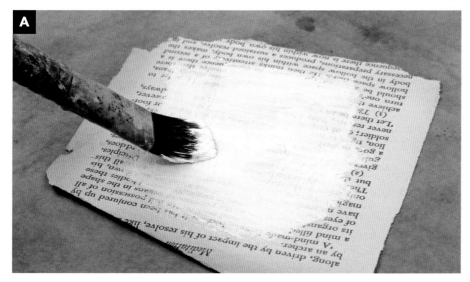

Create the Notes

1. Gather together little pieces of collage papers, roughly 4 x 4 inches (10 x 10 cm). Tear them rather than cutting them so you get nice rough edges. Prepare each piece of paper with a layer of white gesso; this is where you will write your little gratitude note (**A**). Let dry.

2. Write messages of love and gratitude to people, animals, elements, and/ or experiences in your life that you are grateful for (**B**). (Remember, it doesn't have to be a big thing, though it could be.) You can be grateful for the sunshine, a mild breeze, your coat, a beautiful song, or your neighbor smiling at you. It doesn't matter what it is.

3. Once you've written your messages, roll up the papers into little parchment rolls, using pieces of washi tape to hold them together (**C**).

4. On some of your paper rolls, you can add embellishments such as string, ribbon, or stickers (**D**).

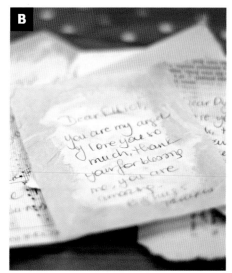

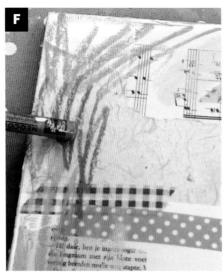

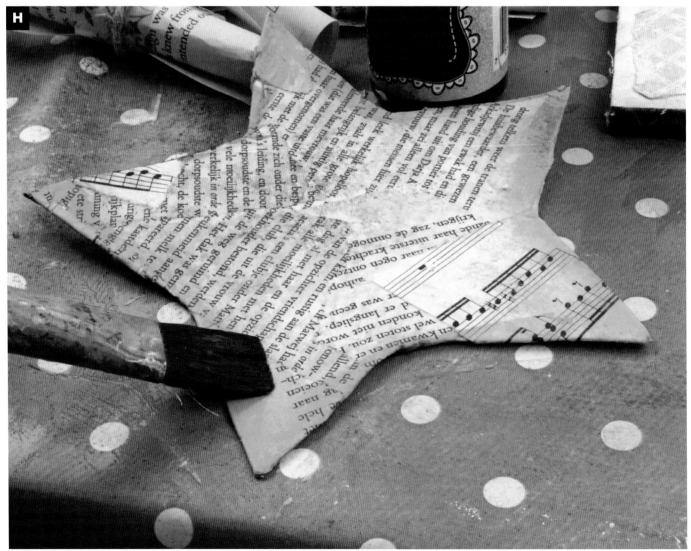

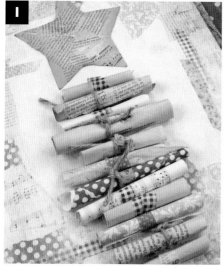

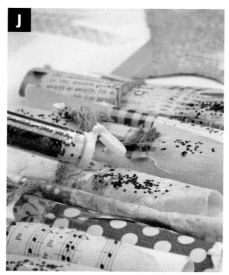

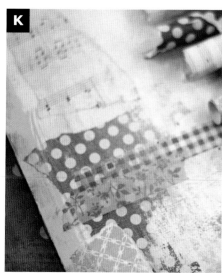

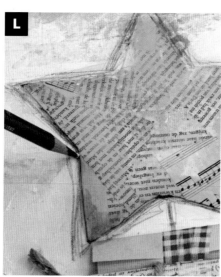

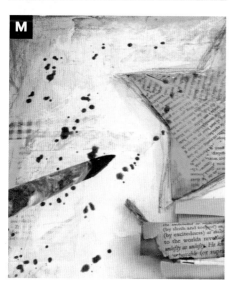

Develop the Background

1. Once you have about eight to twelve notes, start on your background. I'm working on 16 x 12 inch (40.5 x 30.5 cm) watercolor paper. Add collage. Use similar papers to the ones you used for the notes. Put your collage pieces near the edges only, leaving the center of the page untouched. Glue down with gel medium (**E**).

2. Add color over the collaged areas with crayons or watercolor paint (**F**).

3. With a palette knife or hard plastic card, apply white gesso to the center of the page, spreading out to the edges. Wipe away excess gesso with a tissue or baby wipe; you want a milky, transparent layer over your collage (**G**).

Assemble the Project; Add Finishing Touches

1. Lay out your parchments in row. Allow for some space above the row and cut a star (or other symbol you resonate with) out of watercolor paper to be placed above the parchments. The imagery I'm trying to create here is a star on whose tail hang all my blessings. Decorate the star with collage and inks (**H**).

2. Glue down the star and the parchment rolls with gel medium (**I**).

3. Put gel medium on the rolls and then sprinkle with glitter (**J**).

4. Add color to the edges of your painting, as if to frame the star and notes (**K**).

5. Outline your star with color and pencil if you feel it needs it (**L**).

6. As a final touch, I added splatter around the star and notes, plus I added pink dots with a cotton swab (**M & N**).

5

Binding Your Life Book

WHEN I RUN LIFE BOOK ONLINE EACH YEAR, we do approximately fifty-two mixed media projects—one a week—and bind the pages together into one big book when we reach the end of the year. Now that you've done the projects in this book, you may also want to bind your pages together for safekeeping.

Simple Ring Binding

A SIMPLE WAY OF KEEPING all your pages together without going through the effort of binding is by using transparent sleeves in a ring binder. This is the easiest way and most non-invasive way; you won't damage any of your pages. Some people prefer it because many of the other methods require you to alter your paintings some-what. In the Life Book course, I've demonstrated several different ways to bind pages together. If you're interested in bookbinding methods, research these techniques:

- Coptic binding
- Japanese stab binding
- wire/ring binding
- section sewn binding

Because we work on single pages, it's easiest to use a binding method that works best for them. I have, however, managed to bind single pages with methods that are more suited to double pages. For the purposes of this book, I will demonstrate how to easily bind your pages into a ring-bound book.

Supplies Needed

- *Your Life Book pages (and/or other pages you want to include).*
- *Sewing machine.*
- *Binding rings, ribbon, or sturdy thread (possibly leather).*
- *Single-hole punch of some sort (I used both heavy duty and a star-shaped one).*
- *Two pieces of strong cardboard sized as large as your largest painting/page, plus 1 inch (2.5 cm) on one horizontal side.*
- *Papers to decorate your covers.*
- *Ruler, utility knife, and binder clips to keep papers together while stitching.*
- *Watercolor paper to cut into strips.*

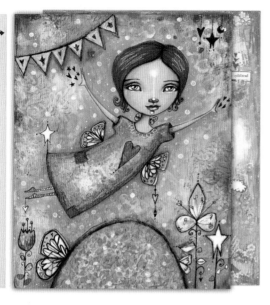

A

2 INCHES
(5 CM)

B

ALLOW
1 INCH
(2.5 CM)
OF STRIP
TO HANG
OVER

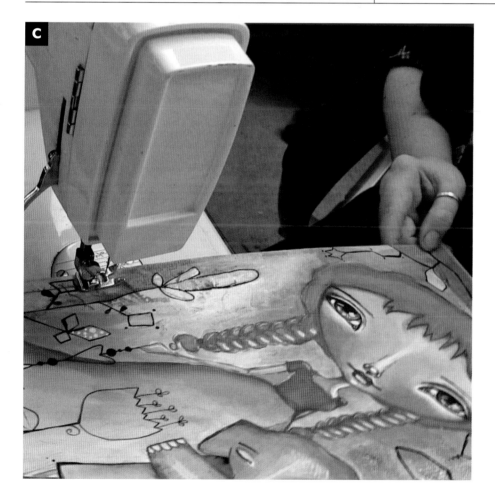

C

Bind Your Book

1. Sort your pages in the order you want them to be in the book.

2. Cut 2-inch (5 cm) strips for all your pages. You need half the number of strips as you have pages (**A**).

3. Once you've got all your strips ready, start stitching your pages together back to back, leaving the strips hanging out by about an inch (2.5 cm). The other inch (2.5 cm) gets stitched in between the two pages (**B & C**).

4. Prepare and decorate your covers. You'll need two sturdy cardboard pieces as large as your largest page. I used two cardboard pieces for each cover and glued them together with gel medium (**D**). You can decorate your covers in a patch-like manner, as described in step 5, or take a more traditional approach by choosing a piece of patterned/decorated paper you like that is 2 inches (5 cm) larger than your cover board on all sides (**D1 & D2**). Glue your cover down onto the piece of paper (**D3**). Then cut off the corners in triangular shapes. Fold the edges inward onto the cover and adhere them with a strong gel medium (**D4**). If you want the cover to be decorated too, cut to size the same or another piece of patterned/decorated paper that speaks to you and glue it down (**D5 & D6**).

5. I decorated my covers with torn pieces of paper in a quilt- or patch-like way. You could do it more neatly if you prefer (**E**).

6. Once you've stitched all your pages together, punch holes in the strips (**F**). Allow for about $7/16$ inch (1 cm) from the top and bottom edges and $7/16$ inch (1 cm) in from the left edge as starting points (**G**). Allow for approximately 2 inches (5 cm) between holes. I like to use a star-shaped hole punch, which are fun but won't be as durable as circular ones.

7. You'll need to punch holes through your covers too. Once you've got all the holes punched, place all your pages and covers in the order you want them bound. Then lay out the rings and start threading (or stacking) the pages on the rings (**H**).

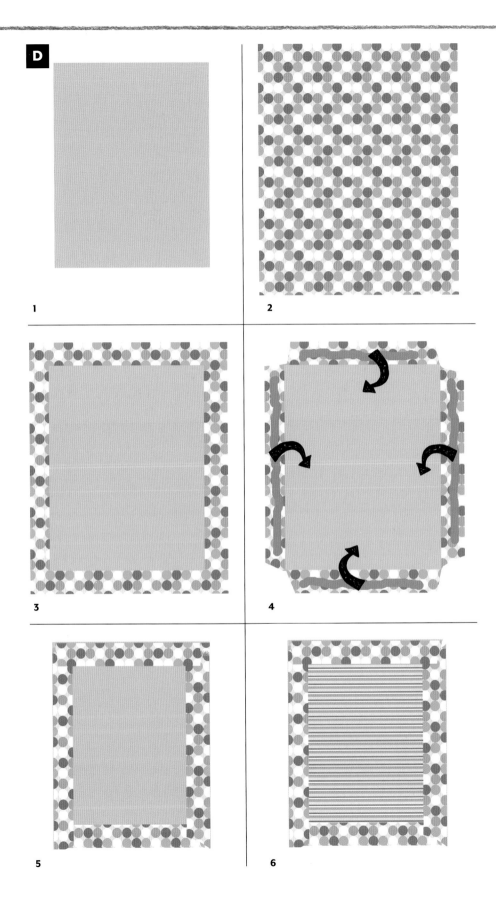

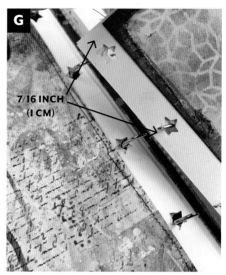

7/16 INCH (1 CM)

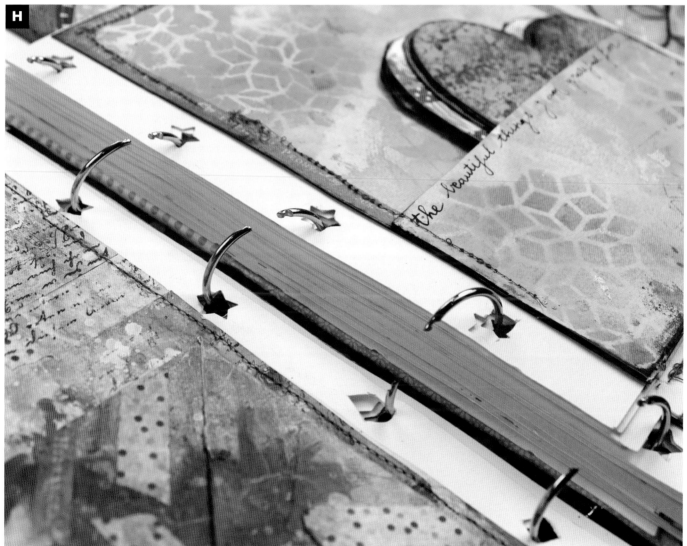

Final Words of Encouragement

DEAR READER, CREATOR, ARTIST, spark of the universe: Remember that you are a glorious expression of the universe. I know it doesn't always feel like it, and things can be tough sometimes, but treat yourself with deep compassion, love, and kindness, if you can. If your creative journey is hard and you're not quite making paintings that you like yet, give yourself time; you require practice. Keep going—you can do this. Enjoy the journey. Focus less on the outcome and more on the process. If you dislike much of what you're creating, go back to the creative things that gave you joy (follow your bliss), even if it's just that one color against the other color. (I recommend just color blocking deep pink magenta against vibrant bright teal—my happy place!) Don't compare your work to other people's work. You have your own unique, beautiful, shining voice.

Your story and your voice matter. You are worthy, loved, and needed. Stick with yourself—you're what it's all about.

Do not believe in failure. Think of Thomas Edison, who said, "I have not failed. I've just found 10,000 ways that won't work." How's that for an awesome reframe? Be good to yourself, precious soul.

Whatever you do, don't stop. Don't give up on yourself or your creative journey. The world is waiting for you and your voice. I believe in you!

Life Book Manifesto

This is the manifesto given to Life Book students who take the online course. Now you're a student too, so it applies to you!

shine your light

You are welcome to be your own, authentic self. We celebrate your shadow and your light. You can shine big and bright, or you can quietly sit at the back of the room. No matter how you show up, you are loved, you are worthy, you are glorious, and you are welcome. Your art is valued and appreciated. When you create art, we see your soul speaking; we see it reaching out, expressing itself. Your nature is creative, and we will provide a safe space for you to explore your artistic yearnings. Your art matters. Your story matters. You matter. On Life Book, it is safe to make mistakes, to dance like no one is watching, to play, to make messy art, to be crazy happy, to blow bubbles, to sing out of tune, to cry, to fumble around, to giggle-snort, to laugh out loud, to be wild, and to find yourself. It is safe to be who you need to be. On Life Book, we encourage our fellow creative friends on their personal and artistic paths. We look to become our own superheroes and our own best friends. We celebrate our positive qualities, we celebrate our triumphs, and we allow space for mourning and grief. We feel our feelings. We lean into discomfort and see where it takes us. We honor our inner world. We sit down with sadness. We sit in the fire and we rise again, like the phoenix. We keep an open mind and heart. We strive to be kind to ourselves and to love ourselves more deeply. We befriend our inner critic so that she may become less critical of us. We dance with our angels; we dance with our demons. We breathe, we dive, and we stand strong. On Life Book, you can play like a child! You can blow bubbles, fling glitter, and jump in muddy puddles. You can dye your hair blue or pink, and you can revel in your paint-stained hands. Wear odd socks, stripy stockings, bear hats, or rainbow nail polish; it's all celebrated here! There are no shoulds or musts, just a gentle encouragement to follow the path that leads you to joy, freedom, kindness, and inner peace. On Life Book, we say yes, we follow our bliss, and we show up without apologizing. We make miracles happen, dance in the rain, and run wild and free. We follow our dreams, but treasure the beauty of the now. We strive to be the change we want to see in the world and to become better versions of ourselves by exploring our inner worlds through our creative practice. We share our hearts, we fly high, and we are true to ourselves and each other. On Life Book, we are artists. We honor you.

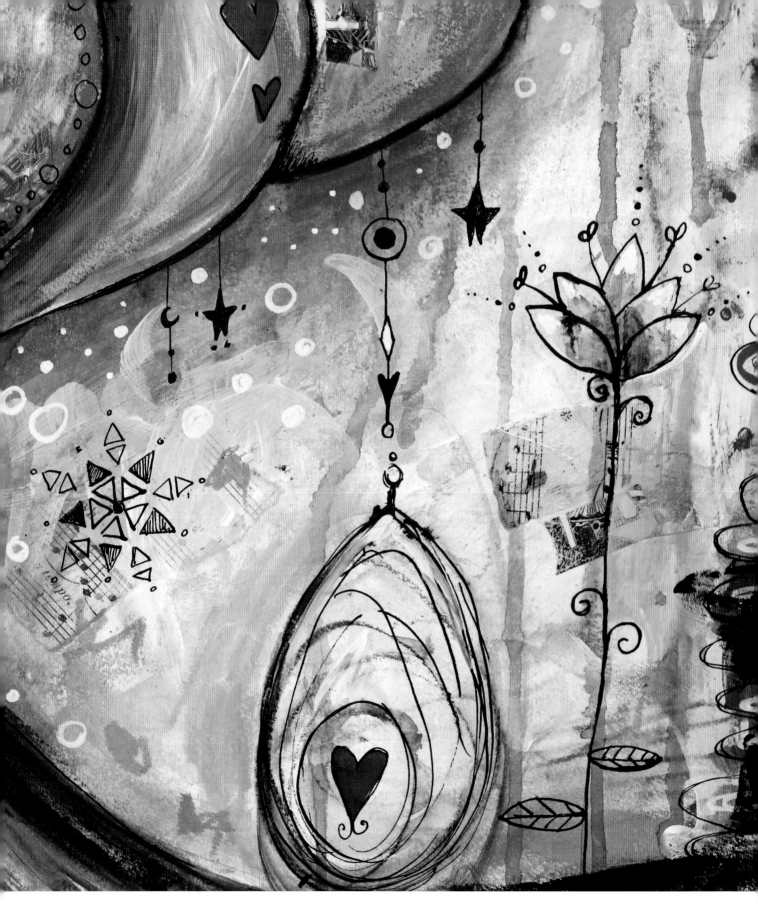

Resources

ENJOY LIFE BOOK ONLINE! Visit www.willowing.org for Life Book and other online art classes!

Learn Nonviolent Communication:

www.cnvc.org
www.nvctraining.com
www.living-compassion.org

**Needs List
(as defined by NVC)**

CONNECTION
acceptance
affection
appreciation
belonging
cooperation
communication
closeness
community
companionship
compassion
consideration
consistency
empathy
inclusion
intimacy
love

mutuality
nurturing
respect/self-respect
safety
security
stability
support
to know and be known
to see and be seen
to understand and
be understood
trust
warmth

PHYSICAL WELL-BEING
air
food
movement/exercise
rest/sleep
safety
shelter
touch
water

HONESTY
authenticity
integrity
presence

PLAY
joy
humor

PEACE
beauty
communion
ease
equality
harmony
inspiration
order

MEANING
awareness
celebration of life
challenge
clarity
competence
consciousness
contribution
creativity
discovery
efficacy
effectiveness
growth
hope
learning

mourning
participation
purpose
self-expression
stimulation
to matter
understanding

AUTONOMY
choice
freedom
independence
space
spontaneity

Contributing Artists

Roxanne Coble

Roxanne (a.k.a. By Bun) is a mixed-media artist, illustrator, and maker of things. Known for her detailed art journaling, her work fuses both mixed-media and painted illustration. Inspired by all things macabre, she creates pages that embrace a balance of humor and dark emotional themes—all while exploring topical events that occur in her personal life. Her work has been featured on the cover of *Art Journaling Magazine* and more recently as guest artist work on the PBS show *Make It Artsy*. Currently, Roxanne works as an artist and freelance art educator in Los Angeles.

• *www.bybun.com*
• *www.instagram.com/bybun*
• *www.youtube.com/user/madebybun*

Andrea Gomoll

Andrea is a mixed-media artist and illustrator from Berlin, Germany, where she lives with her husband, Thomas, and two crazy cats. Watercolor is her medium of choice, but in a less traditional way—she loves to combine it with inks, markers, collage, and lots of texture for a unique mixed-media look. She has a whimsical style; she loves colorful illustrations and playful big-eyed girl portraits. She loves to inspire others with her creative creations and to enable others to lead a creative life by teaching art (online) classes.

• *www.andrea-gomoll.de*
• *www.instagram.com/Cre8tiveCre8tions*
• *www.facebook.com/CreativeCreationsByAndrea*
• *www.youtube.com/user/AndreaGomoll*

Effy Wild

Effy has been using art journaling as a way to meet herself on the page since 2009. She teaches online, runs Journal52 and #MiniMoleyDaily, and offers full length and mini (some free) workshops in her teaching network at www.learn.effybird.com. She also blogs at www.effywild.com. Effy considers herself a journal artist, and her emphasis is always on process over finished product. She lives in Ontario with her lovely dog, Sookie, and works from her home studio.

• *http://journal52.com*
• *www.facebook.com/groups/minimoleydaily*
• *www.learn.effybird.com*
• *www.effywild.com*

Alena Hennessy

Alena began making art at a very young age, way before she could write. She would spend hours upon hours drawing on the back of her grandmother's dittos from school, making up imaginary worlds of all sorts of characters and scenes. Since then, her love of creating has evolved, branching out with a deep desire to assist others in finding their true voice in painting and mixed-media art.

Alena is the author of *Cultivating Your Creative Life, The Painting Workbook*, and *Intuitive Painting Workshop* and a beloved teacher of the art-making process, both online and at select retreats. Her work has been featured in numerous magazines and other publications, including *Dwell*, the *Washington Post*, *Somerset Life*, *Spirituality & Health*, *ReadyMade*, *Redbook*, *Stitch*, *Victoria*, and *Natural Health*, as well as featured on *Good Morning America* and pilot shows for ABC Studios. Her paintings have been exhibited across major cities in the United States, along with several museum shows. Alena is also a flower essence practitioner, a Reiki master, and an energy healer. Through grace and intuitive guideposts, she calls the beautiful town of Asheville, North Carolina, her home. As a facilitator, her intention is that each participant leave a little more transformed, content, and open to wild possibility.
• *www.alenahennessy.com*

Mystele Kirkeeng

Mystele is a self-taught acrylic and mixed-media outsider/folk artist living in Illinois by way of Texas. Her work focuses mainly on imaginary female subjects with wonder, hope, and encouragement as underlying themes.
• *www.mystele.com*
• *www.facebook.com/WonderWorksbyMystele*
• *www.etsy.com/shop/WonderWorksbyMystele*

Ivy Newport

Ivy is a published mixed-media artist, art instructor, and creative guide. Her online collection of artistic workshops has served thousands of students internationally. She strongly believes that every soul is creative, and finding ways to express that creativity is paramount to joy and healing. She currently lives in Portland, Oregon, with her husband and two daughters.
• *www.ivynewport.com*

Acknowledgments

Wow—putting a book together, I found out, is not an easy feat! It took a lot of effort, late nights, and copious amounts of caffeine and cuddles to get it into a shape we were all happy with! I couldn't have done this alone, of course. My deep gratitude goes out to the following amazing people:

♥ **Andy Mason,** for being my husband, friend, therapist, and wise guru and for his undying love and support.

♥ My children, **Dylan & Elliot,** who inspire me every day to become a better version of myself. They are the cutest, most beautiful "things" I've ever created, and they've graciously let go of some precious mummy time so that this book could be birthed.

♥ **Gracie Howle** (part unicorn, part mermaid), for being my awesome friend, all-around loving committed support, and a Willowing Team member extraordinaire.

♥ And **Maddie Turner** (part fairy, part rainbow), for being my wonderful friend and for holding the Willowing Fort with such eloquence, strength, and commitment while I was hunkered down in the writing cave.

♥ I also want to thank all past and present **Life Book Students** who have joined Life Book online and made this such an incredible experience. Their art, authenticity, sharing, and support of each other touches and moves me every day.

♥ Deep gratitude goes out to all past and present **Life Book Teachers** who have made Life Book such a wonderfully varied, interesting, and inspiring experience. Thank you for sharing your knowledge, techniques, and insights with us over the years.

♥ A huge thank you goes out to the **contributing artists** in this book: Effy Wild, Ivy Newport, Mystele Kirkeeng, Alena Hennessy, Andrea Gomoll, and Roxanne Coble.

♥ Thanks to **Joy Aquilino** at Quarry for reaching out to me and getting me on board the book-making train. Thank you for all your hard work. Thank you for believing in me and the book and for your eloquence and patience while working with me!

♥ Thanks to **Marshall Rosenberg** for developing NVC (Nonviolent Communication), which radically changed my life, and for opening my eyes to an ever more compassionate, life-enriching way of living.

About the Author

Tamara Laporte ("willowing") is a creative catalyst to thousands of beautiful people. She is a celebrated mixed-media artist and art teacher who has been running her own creative business since 2008. Her work can be described as mixed-media folk art with a focus on magical realism.

It ranges from whimsical children's illustrations to a more stylized fantasy art. Love, mystery, innocence, hope, spirituality, kindness, and self-connection inspire her artwork. Symbolism and layering play a big part in her work. Her paintings often contain healing themes, uplifting messages, and inspirational poetry.

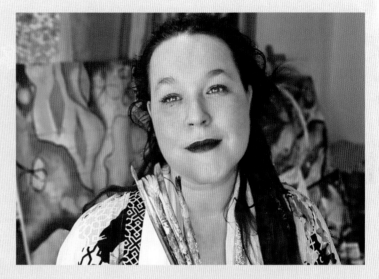

She believes that the act of creating art can be a gateway to healing and personal growth. Often, her art classes contain an element of self-development as well as art techniques. She is deeply devoted to helping people get in touch with their creative fire and would love to help you get in touch with the artist in you!

Tam is the inventor and creator of Life Book, a yearlong art course that includes some of the most celebrated mixed-media and personal development teachers out there. Since its inception, it's been joined by more than 16,000 people who've gained tremendous artistic and personal skills through it. Deeply passionate and caring for the well-being of the world and its people, Tam works tirelessly to bring uplifting, nourishing, creative, and empowering content to her amazing tribe of more than 34,000 souls.

Her work and articles have been published in several art magazines and books, and she's been interviewed for several online radio stations and summits. She runs a variety of popular art classes at her online art school (www.willowing.org), which has more than 28,500 members and grows by about 150 to 200 mixed-media enthusiasts each month!

Tam lives and works in the south of England with her handsome husband, Andy, her two magical boys, Dylan and Elliot, four guinea pigs, and Gizmo the crazy dog. Her two awesome team members in the studio are the glitter-filled Gracie Howle and the wildly mesmeric Maddie Turner.

Index